Franschhoek

& Rickety Bridge

Franschhoek
& Rickety Bridge

A place of extraordinary beauty, food and wine

TEXT AND PHOTOGRAPHY BY
Gerald & Marc Hoberman

UNA PRESS, INC.
in association with
THE GERALD & MARC HOBERMAN COLLECTION
CAPE TOWN • LONDON • NEW YORK

To the vintners and vineyards of Franschhoek and to
future generations, custodians of the land.

DUNCAN SPENCE

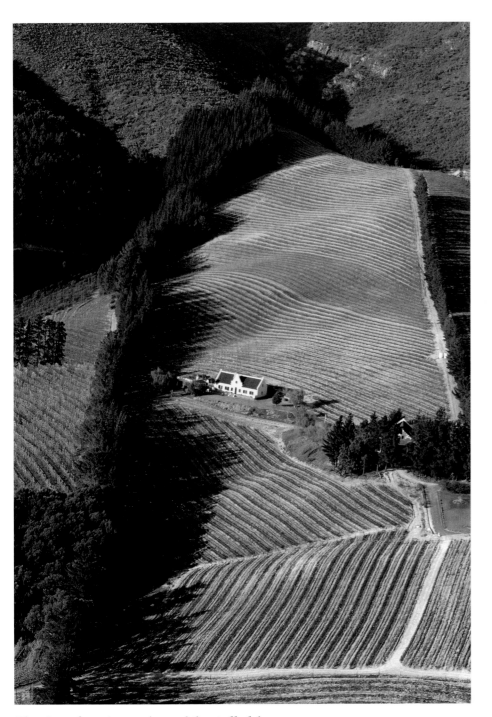

The view of soaring eagles and the stuff of dreams

CONTENTS

Acknowledgements **7**

Map **8**

Foreword **9**

Introduction **11**

Franschhoek & Rickety Bridge **13**

Index **112**

Concept, photography, design, and production control: Gerald and Marc Hoberman
Reproduction: Marc Hoberman
Text: Gerald Hoberman
Editor: Roelien Theron
Layout: Hanneke du Toit
Index: Sandie Vahl
Cartography: Peter Slingsby

www.hobermancollection.com

ISBN 0-9729822-1-3

Franschhoek & Rickety Bridge is published by Una Press, Inc. in association with The Gerald & Marc Hoberman Collection (Pty) Ltd.
Reg. No. 99/00167/07. PO Box 60044, Victoria Junction, 8005, Cape Town, South Africa
Telephone: 27-21-419 6657/419 2210 Fax: 27-21-418 5987 e-mail: office@hobermancollection.com

For copies of this book printed with your company's logo and corporate message contact The Gerald & Marc Hoberman Collection

International marketing, corporate sales and picture library
Laurence Bard, Hoberman Collection (USA), Inc. / Una Press, Inc.
PO Box 880206, Boca Raton, FL 33488, USA
Telephone: (561) 542 1141 e-mail: hobcolus@bellsouth.net

Agents and distributors

United States of America, Canada and Asia	*Australia*	*Germany*	*Namibia*	*Republic of Ireland and Northern Ireland*	*United Kingdom*
BHB International, Inc.	Wakefield Press Distribution	Herold Verlagsauslieferung & Logistik GmbH	Projects & Promotions cc	GSR Distributors Ltd.	DJ Segrue Ltd.
302 West North 2nd Street	Box 2266	Raiffeisenallee 10	PO Box 96102	47 Marley Court	7c Bourne Road
Seneca, SC 29678	Kent Town, SA 5071	82041 Oberhaching	Windhoek	Dublin 14	Bushey, Hertfordshire
Tel: (864) 885 9444	Tel: (0)8-8362 8800	Tel: (089) 61 38 710	Tel: (0)61-25 5715/6	Tel: (0)1-295 1205	WD23 3NH
Fax: (864) 885 1090	Fax: (0)8-8362 7592	Fax: (089) 61 38 7120	Fax: (0)61-23 0033	Fax: (0)1-296 6403	Tel: (0)7976-273 225
e-mail: bhbintl@bellsouth.net	e-mail: sales@wakefieldpress.com.au	e-mail: herold@herold-va.de	e-mail: proprom@iafrica.com.na	e-mail: murray47@eircom.net	Fax: (0)20-8421 9577
					e-mail: sales@djsegrue.co.uk

Printed in Singapore

Acknowledgements

The people of Franschhoek are exceptional. They are passionate about their town and its natural beauty, and they are proud of their traditions and world-renowned viticulture. Some have come from the far-flung corners of the earth and have made a valuable contribution by bringing their culture and fine cuisine to the region.

It was a great privilege to have met so many of the townsfolk. Without exception, they welcomed us into their world with enthusiasm and charm. This publication would not have been possible without their support. We are especially grateful to those listed below.

Gerald and Marc Hoberman

Annemarie Guthridge

Attie Steyn

Basse Provence: Theo Lotter, Maggie Marjoram

Boschendal: Eddie Turner

Cabrière Estate: Achim von Arnim

Clarke's Bookshop

Daphne Stephens

David, Michelle and Sarah Walters

Dewdale Trout Farm & Trout Fishery: Krijn Resoort, Jacques van Rhyn

Dieu Donné: Stephan du Toit

Franschhoek Conservation Study

Franschhoek Municipality

Franschhoek Vallée Tourisme: Richard von Hoesslin

Huguenot Fine Chocolates:

Denver Adonis, Penny Gordon, Danny Windvogel

Huguenot Memorial Museum: Juna Malherbe

Jeremy Astfalck

Kei Carpets: Mala Anderson

La Bri Holiday and Olive Farm: Christo and Martina Strydom

La Fromagerie at La Grange: Hugo Blaissè

L'Ormarins: Wanda Vlok

La Petite Ferme Restaurant and Guest Suites: Carol, Josephine, John and Mark Dendy Young, Natalie Edgecumbe

Le Quartier Français: Susan Huxter, Linda Coltart, Margot Janse

National Botanical Institute: Edwina Marinus

P. Smit

Pearl Valley Signature Golf Estate & Spa: Leon Kruger

Phillida Brooke Simons

Résidence Klein Oliphants Hoek: Camil and Ingrid Haas

Rickety Bridge Winery: Butch McEwan, Mariaan and Rowan Dawson, Wilhelm van Rooyen

SAWIS, Yvette van der Merwe, Debbie Wait

Shirley Parkfelt

The Old Corkscrew: Jenni Attridge

Todeschini and Japha Architects and Town Planners

Topsi & Company: Topsi Venter

Vignerons de Franschhoek: Felicity Rennie

Village Museum

FRANSCHHOEK

DIRECT ROUTE FROM CAPE TOWN,
83 KM ON THE N1, EXIT 59

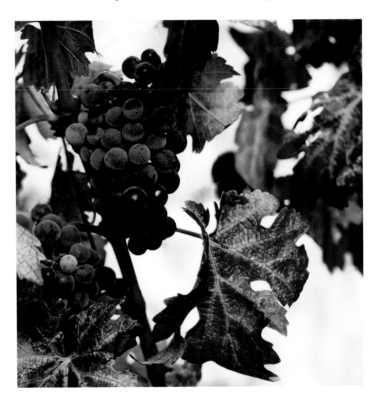

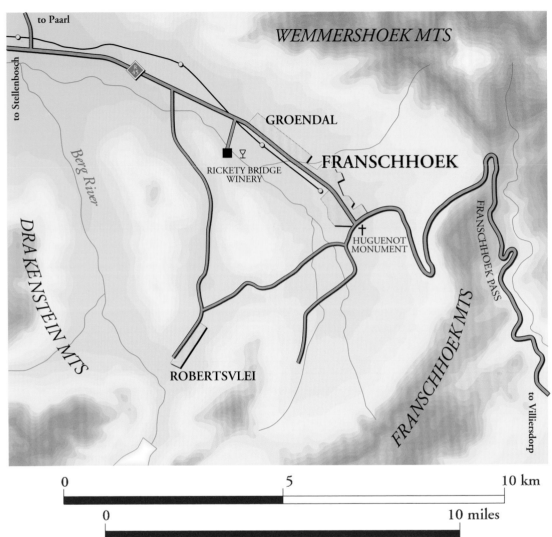

to Paarl

WEMMERSHOEK MTS

to Stellenbosch

GROENDAL

FRANSCHHOEK

RICKETY BRIDGE
WINERY

Berg River

HUGUENOT
MONUMENT

DRAKENSTEIN MTS

FRANSCHHOEK PASS

FRANSCHHOEK MTS

ROBERTSVLEI

to Villiersdorp

| 0 | | 5 | | 10 km |

| 0 | | | 10 miles |

N

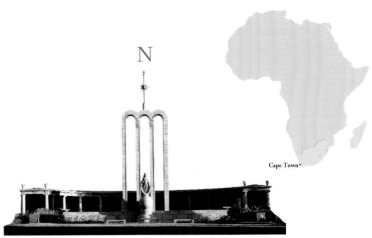

Cape Town

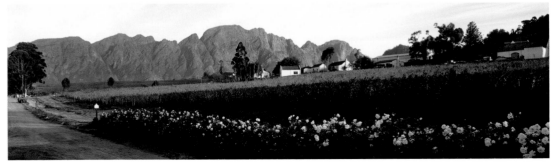

FOREWORD

eat sleep drink

FRANSCHHOEK

Franschhoek has, over the past fifteen years, become known as the Gourmet Capital of South Africa. This in no small way has been supported by the rapid increase in quality wines being produced in the Franschhoek Valley. It is an honour for me to acknowledge the production of a book commissioned by Duncan Spence, owner of the winery, Rickety Bridge. He has recognised that the farm, with its well-restored Cape Dutch homestead, provides a wonderful example of an estate in the Cape Winelands of South Africa. This book showcases the exquisite beauty of Franschhoek and its surroundings, and includes all that has made it so popular with both visitors and investors. We are proud to have achieved an environment that complements the natural splendour we have been blessed with and are delighted to have had Gerald and Marc Hoberman help us present it to the world so creatively. The people of Franschhoek enjoyed the time they spent in assisting them to highlight the special attributes of the valley.

RICHARD VON HOESSLIN
CEO, FRANSCHHOEK VALLÉE TOURISME

INTRODUCTION

Franschhoek with its awesome mountain scenery and undulating vineyards is magnificent. This sun-drenched valley on the renowned Cape wine route near Cape Town is significant among the grape-growing regions of the world. Favourable terroirs, carefully chosen cultivars, a unique microclimate and a viticultural tradition that dates back to 1694 – when the Huguenots planted the first vines in the valley – combine to produce a diverse range of fine wines. From crisp, straw-coloured whites and honey-coloured dessert wines to burgundy and plum-coloured reds, Franschhoek's wines are celebrated by enthusiasts and connoisseurs around the world.

Visiting the Franschhoek Valley is an indelible experience. Majestic mountains, often of a purplish hue, sometimes with snowcapped peaks in winter, provide a stunning backdrop to the neat rows of freshly ploughed earth and vines which dazzle with their russet colours in autumn. Occasionally, roses bloom at the edges of vineyards. Thatched Cape Dutch homesteads and wine cellars with elegant gables and thick, whitewashed walls punctuate the landscape. On these estates, wine is laid to rest in French oak barrels, and in the unhurried silence of cool, dark maturation cellars, alchemy takes its course.

Franschhoek, literally translated as 'French Corner', is often described as the Gourmet Capital of South Africa. Here, excellence is the touchstone. From hallowed haute cuisine restaurants to the bonhomie of bistros, fine French fare and wines of the region are consumed with delight by discerning international visitors and locals alike. Warm and friendly Cape hospitality and infinite wine-tasting opportunities are the order of the day. A visit to Rickety Bridge Winery, the world-renowned boutique winemakers of distinction, is an experience not to be missed.

Franschhoek is also the source of crystal clear spring water, which is bottled in the area, as well as excellent honey.

Charming country inns, guesthouses and auberges abound in and around this vibrant valley of some 7,000 inhabitants. Art and craft shops of a high order are a browser's delight. The Huguenot Monument and Memorial Museum provide a fascinating insight into the history of the valley.

Anyone for a game of boules, a baguette and a glass of local bubbly? This valley of the Huguenots is a 'must see' for any visitor to South Africa. Ask anyone who's been there!

GERALD & MARC HOBERMAN
FRANSCHHOEK

Wine can of their wits the wise beguile.
Make the sage frolic, and the serious smile.

HOMER, *Odyssey* **(NINTH CENTURY BC)**

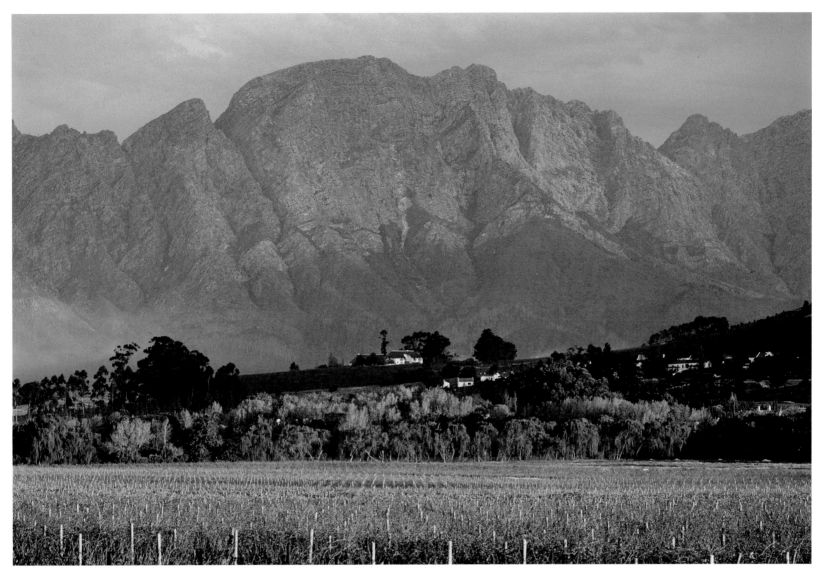

CAPE WINELANDS

The Cape Winelands is arguably the most spectacular grape-growing region in the world. It is unrivalled for its breathtaking scenic splendour of awesome purple mountains and undulating sun-drenched vineyards, its temperate climate and its favourable terroirs.

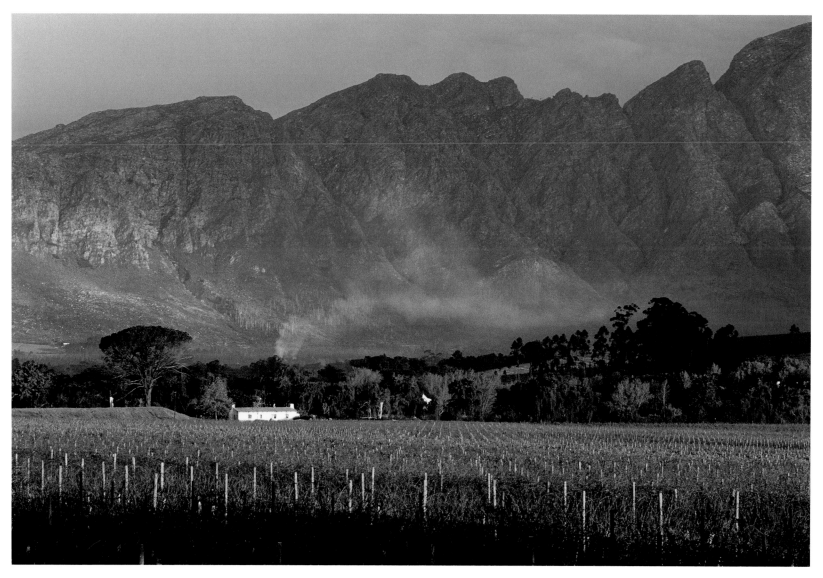

CULTIVAR PROFILE OF FRANSCHHOEK

South Africa is the eighth largest wine-making country in the world. Its vineyards yield an average of 530 million litres of wine per annum, of which some 379 million litres are sold locally. There are about 390 cellars in South Africa. France is the largest wine producer in the world with a 22% market share. The grape production profile in the Franschhoek Valley by the end of 2002 was: Sauvignon Blanc 16.6%, Cabernet Sauvignon 14.4%, Chardonnay 12.3%, Semillon 9.5%, Merlot 9.4%, Chenin Blanc 8.7%, Shiraz 8.4% and Pinotage 4.3%. A range of other varieties constituted 16.4% of the profile.

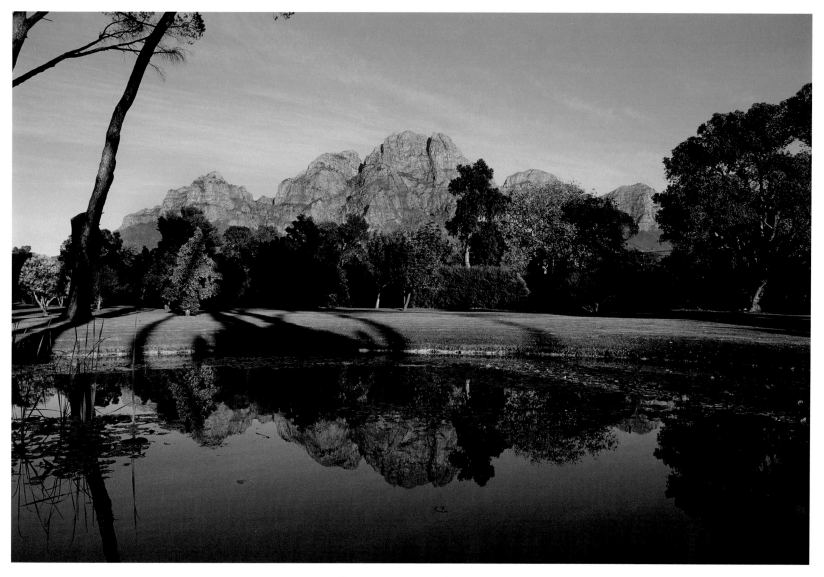

SIMONSBERG AT DAWN

Simonsberg mirrored in placid waters; the chartreuse sparkle of green lawns; the crisp, bracing air of a country morning – awesome, inspiring and rejuvenating.

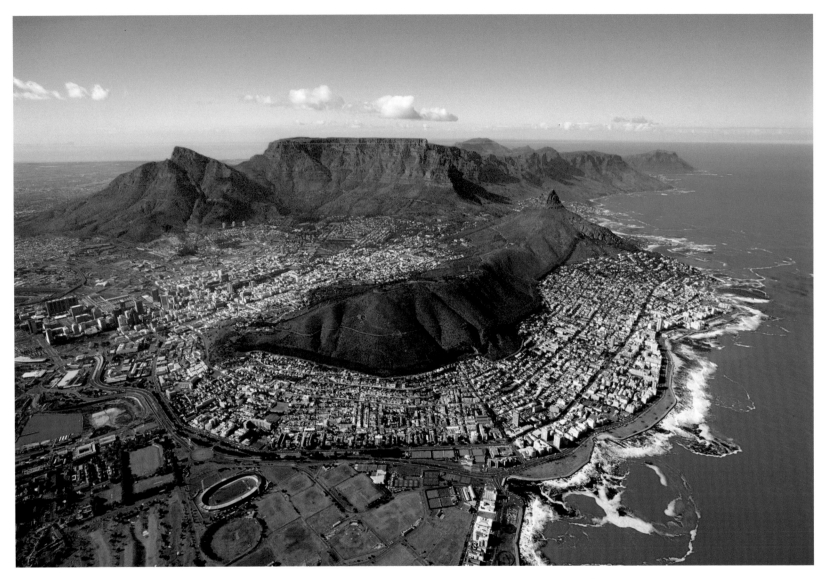

CAPE TOWN – 'THE FAIREST CAPE IN ALL THE WORLD'

Franschhoek is a mere eighty-three kilometres from world-renowned Cape Town, a premier tourist destination.

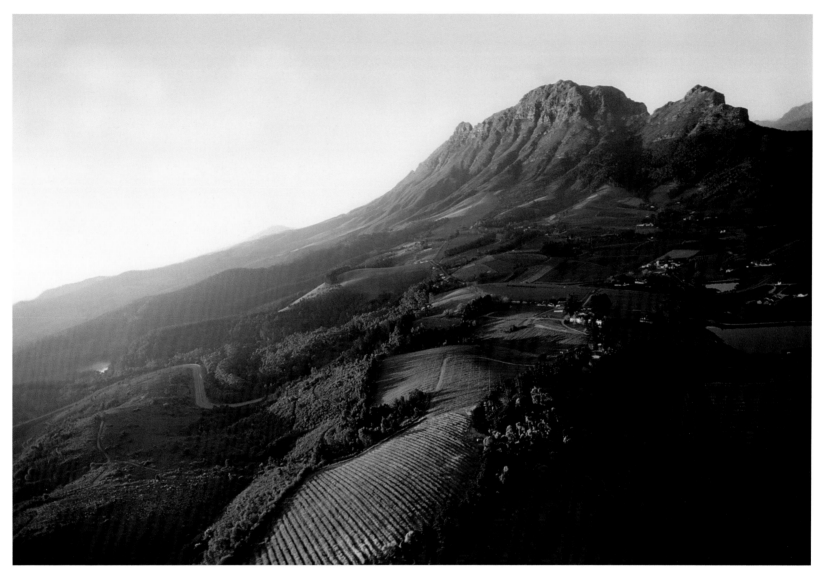

THE SCENIC CAPE WINE ROUTE

Mantled in burnished shades of olive, emerald and cinnamon, the Helshoogte pass, *en route* from Stellenbosch to Franschhoek, is a fine sight at sundown. Its vine-clad foothills are reminiscent of velvety corduroy cloth.

The Valley of the Elephants

The Franschhoek Valley was originally known as Oliphantshoek (Elephants' Corner). It was named for the herds of elephant that were regularly encountered there by explorers and settlers. The long grass, bushes and trees (*olienhout*, *witels*, *keurtjiebome*) found in abundance in the remote valley made it ideal elephant country. Elephant cows probably found the isolation of the valley ideal for raising their calves. The last elephant and her calf were seen in the Franschhoek Valley around 1860.

THE HUGUENOTS

The marriage of the young Prince Henri de Navarre, a Huguenot (French Protestant), to Marguerite de Valois, sister of the despotic Catholic King Charles IX, on 18 August 1572 in Paris, was ultimately to send ripples way across the ocean to the distant shores of South Africa. The massacre of the Protestants that followed the wedding rekindled the Wars of Religion in France. Just over a century later, in 1685, the king of France, Louis XIV, revoked the Edict of Nantes (1598) which had guaranteed religious freedom and protected the French Protestants. Protestantism was outlawed and thousands of French Huguenots fled to Britain, Germany and Switzerland to save their lives and uphold their religious convictions. In 1688, 277 Huguenots crossed the tempestuous Atlantic Ocean, braved the notorious Cape of Storms and landed at the Cape of Good Hope.

Wine was an important commodity, especially as a stable source of liquid sustenance, on the high seas to and from the East. The Dutch, who established a refreshment station at the Cape for ships *en route* to the East, granted the Huguenots, who were good farmers and industrious and skilled in business, land at Oliphantshoek. These farmers were poor and conditions were initially harsh but – and one could only speculate – the valley's extraordinary natural beauty and sunny climate must have made their spirits soar. Notwithstanding the religious freedom at the Cape, the Huguenots were forced by a policy of assimilation to give up their mother tongue in favour of Dutch. Today, countless South Africans have French names but do not speak French. Huguenots in France regained their religious freedom at the time of the French Revolution in 1789.

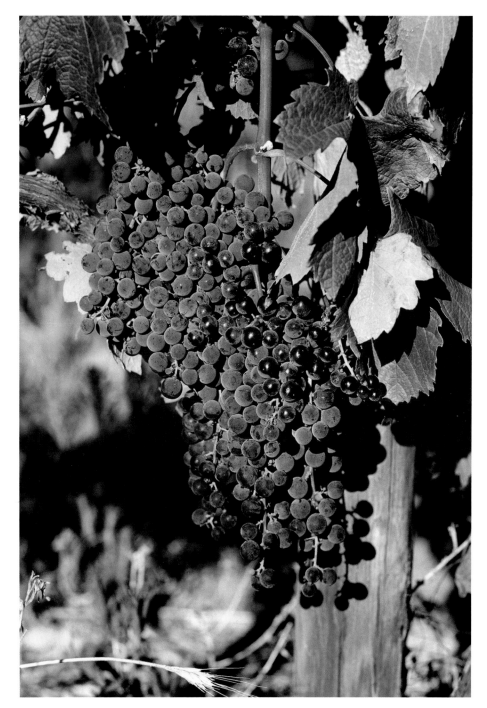

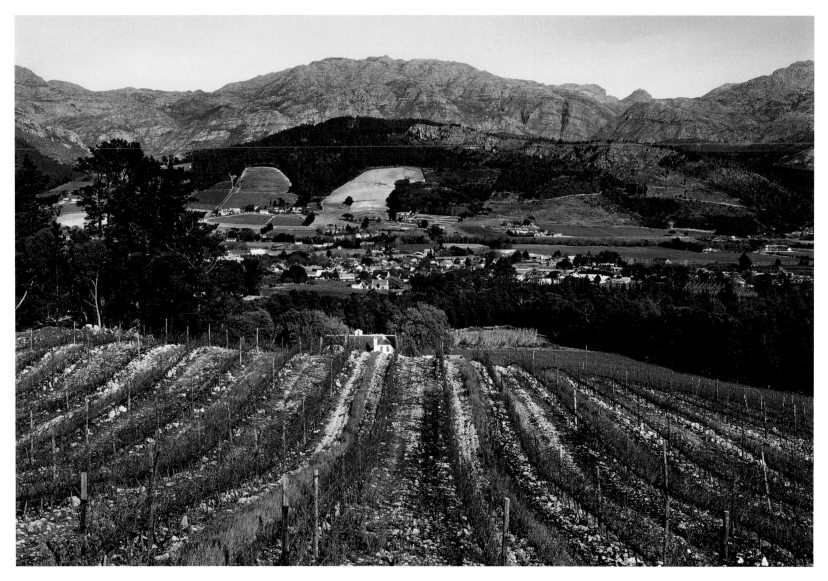

VIEW FROM DIEU DONNÉ

The literal translation of Dieu Donné is 'God given' or 'gift from God'. Situated in a spectacular theatre of mountains, the aptly named Dieu Donné estate overlooks many famous valley landmarks below, including its neighbour, Rickety Bridge Winery.

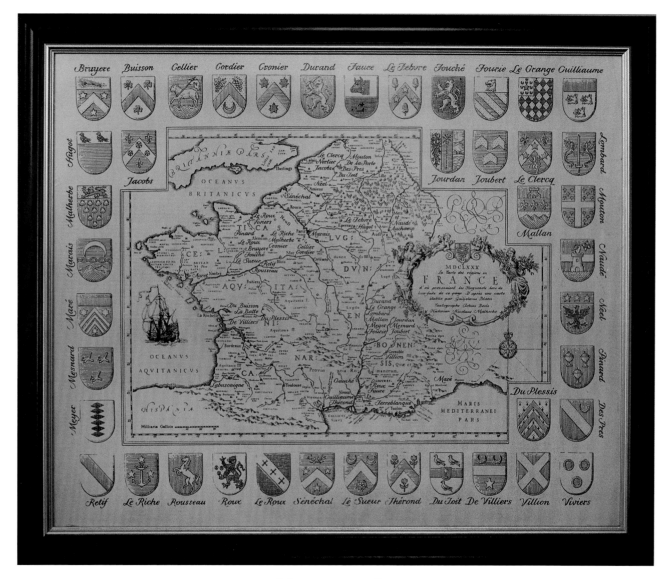

Mapping the Past

This map of France (*circa* 1680) by cartographer Tobias Beele and historian Nicolas Malherbe shows the origins of the French Huguenots who settled in South Africa, their family names and their family crests. The history of the word 'Huguenot' is uncertain. The name was possibly derived from small coins known as *huguenots* in the time of King Hugo Capel. At the Cape, the name 'Huguenot' was not initially used. Early documents and travel books refer to the first French speakers at the Cape as *franche vluchtelingen*, *de Franche gereformeede vlugtelingen*, *de France*, *fransen refugees* and *de franse coloniers*.

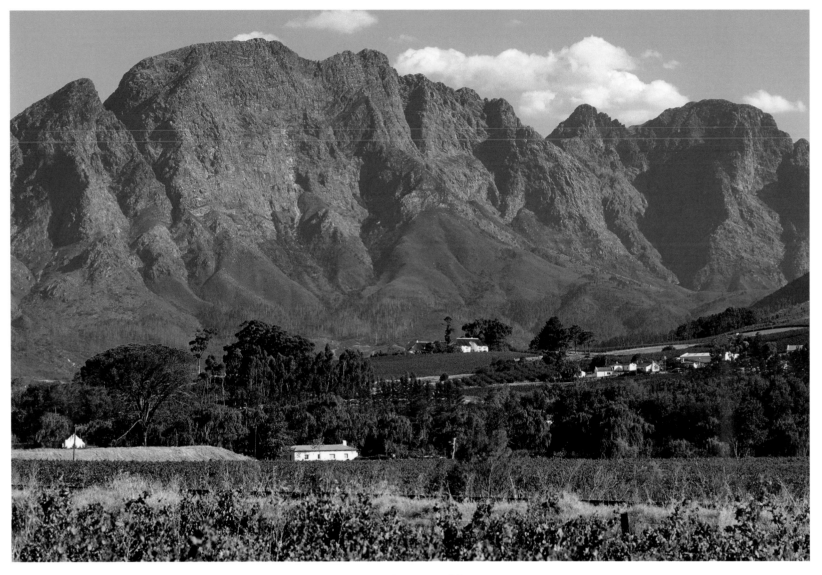

VALLEY OF THE FRENCH HUGUENOTS

This area was first referred to as *de France Hoek* (French Corner) in 1713, as it was inhabited mainly by French speakers. On a 1795 map of the valley, drawn by L.S. de la Rochette, the name is given as *Frans Hoeck of la Petite Rochelle*. In 1805 the commissioner-general of the Batavian Republic at the Cape, J.A.U. de Mist, renamed the area Franschhoek. The name also applied to the new congregation, which was established in 1845, as well as the municipality, which came into being in 1881.

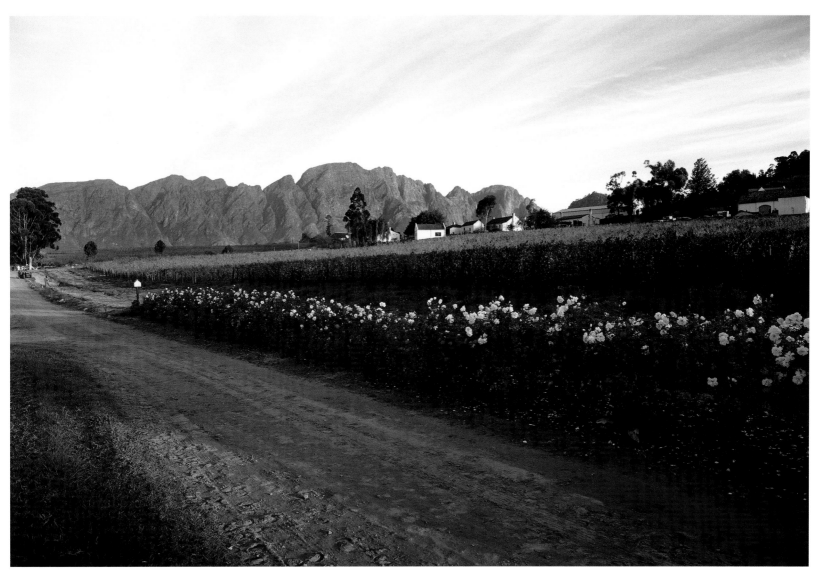

A WINTER'S DAY

The exquisite serenity of Franschhoek at the end of a sunny winter's day brought exhilaration – there was nowhere on earth I would rather have been at that moment!

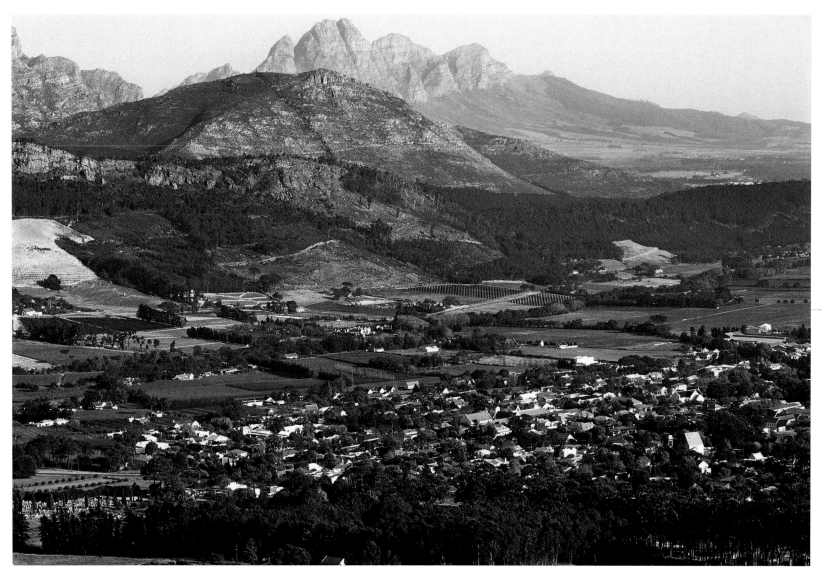

GOURMET CAPITAL OF SOUTH AFRICA

The picturesque Franschhoek Valley is a jewel in the crown of the Cape Winelands. It has a proud tradition of French viticulture dating back to 1694. Franschhoek's award-winning wines are matched by the village's internationally famous *haute cuisine*, which has earned it the epithet 'Gourmet Capital of South Africa'.

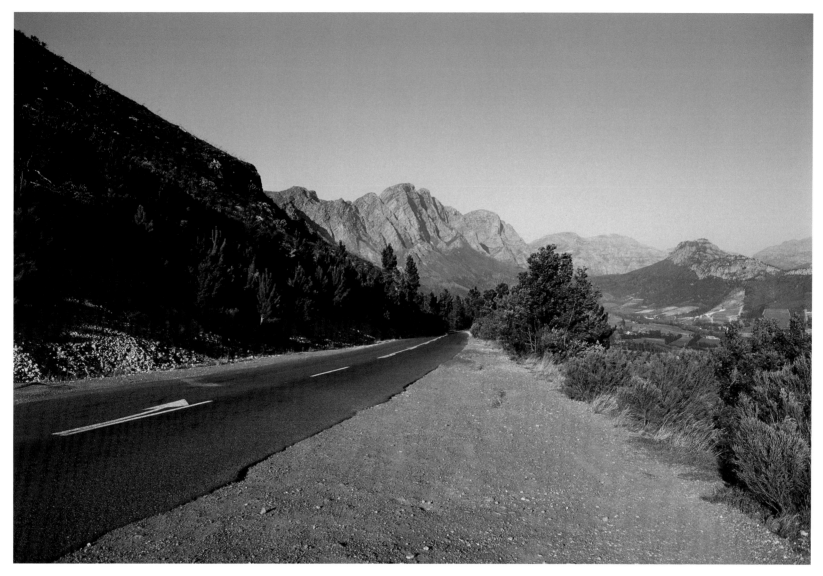

Cats' Road

Early European settlers found the trail from the Franschhoek Valley to the interior, which had been established by migrating elephants, so narrow that they could only negotiate it on horseback. In 1818 Samuel Johannes Cats was awarded a contract to construct a pass over the Franschhoek mountains for 8,000 rix-dollars. Cats' Road was not easy to traverse and in 1822 work began on a new pass. The men of the Royal Africa Corps, who were awaiting passage on a ship to Sierra Leone, were seconded to build the pass by order of Governor Lord Charles Somerset. The present pass was built in 1933. Several improvements were made to this scenic mountain road in 1960.

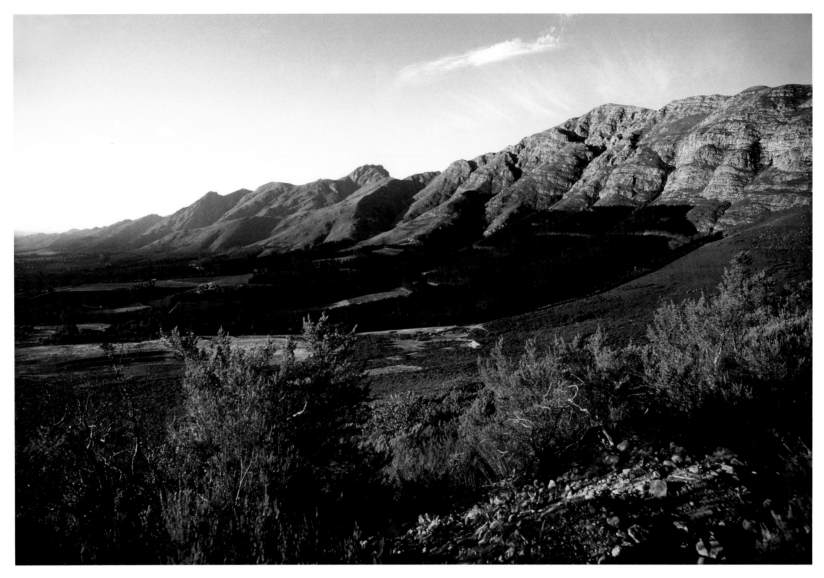

FRANSCHHOEK AND WEMMERSHOEK MOUNTAINS

When the first pass over these mountains was built in 1818, provision was made for three outspan sites, as it was estimated that an ox-wagon would take two and a half hours to negotiate the crossing. The Franschhoek pass is well worth a visit at daybreak for a dramatic view of the Franschhoek Valley and the majestic mountains beyond. To the immediate right are the Franschhoek mountains and in the distance are the Wemmershoek mountains.

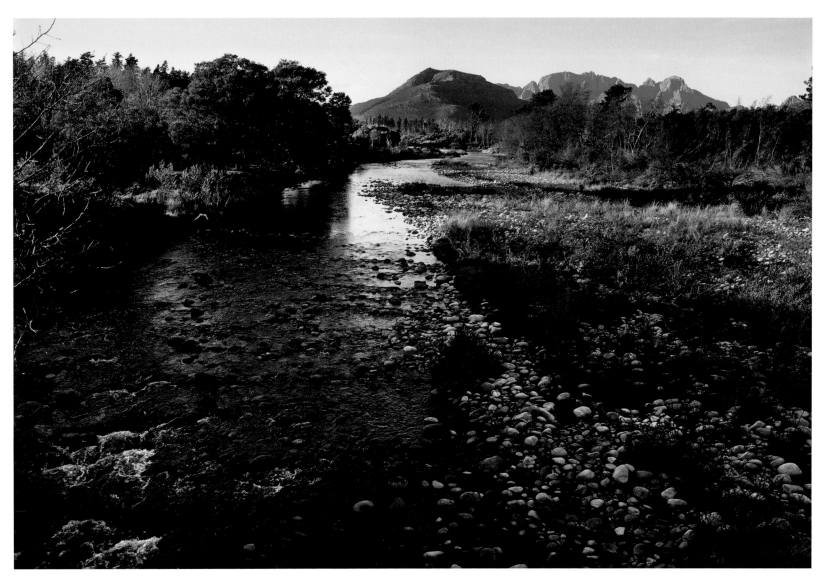

RIO DE SANTIAGO

Originally named Rio de Santiago and aptly renamed Berg River by Abraham Gabbema in 1657, this important water course runs through Franschhoek. It is a tranquil water source, ideal for trout fishing or picnicking. In winter it transforms into a hive of activity during the world-renowned Berg River Canoe Marathon. The annual 228-kilometre race starts a bit further downstream in Paarl and ends four days later in Velddrif on the west coast. This photograph was taken from the Berg River railway bridge just outside the village. Erected in 1904, it is no longer in use.

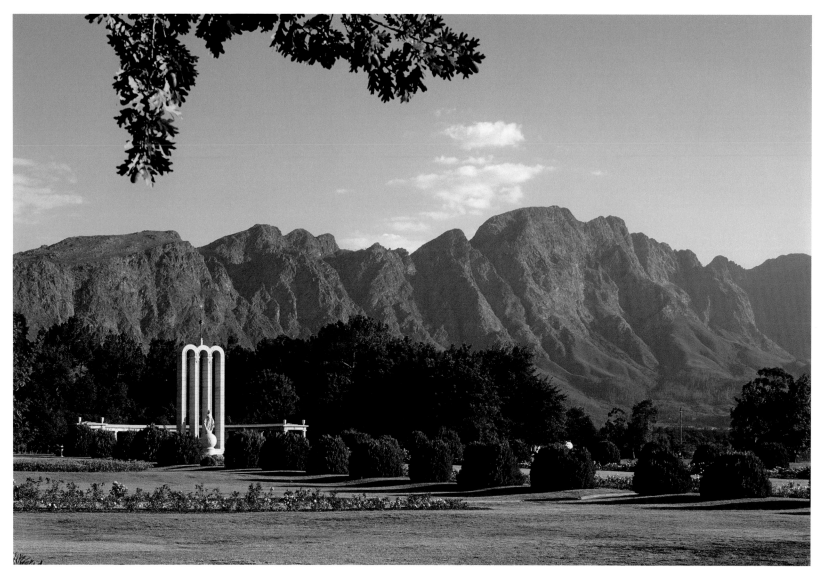

Huguenot Monument

Set against an awesome mountain backdrop, the beautiful Huguenot Monument at the end of Huguenot Road is a fitting tribute to Franschhoek's early settlers. Designed by J.C. Jongens, it was erected on dedicated ground in 1943 in honour of the French Huguenots and their contribution to South African culture. The three arches symbolise the Holy Trinity. They are surmounted by the Sun of Righteousness and, above it, the Cross, a symbol of Christian faith.

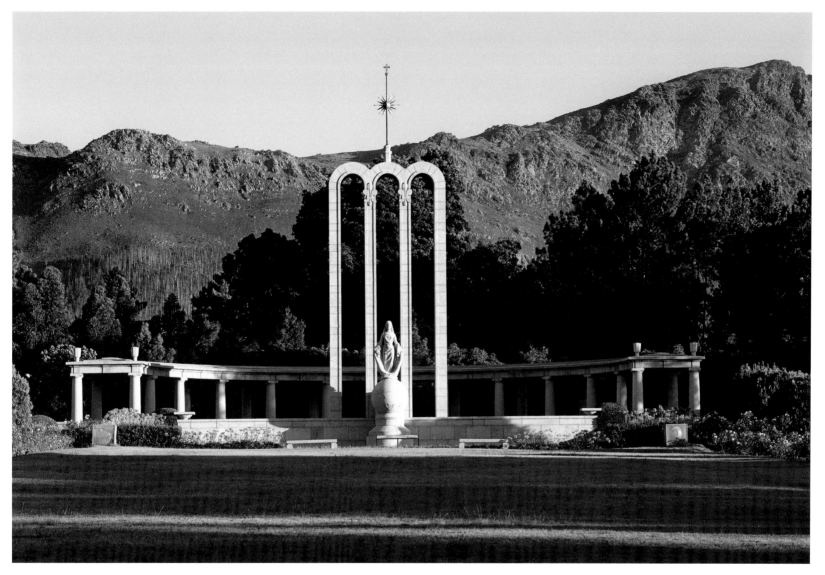

A Symbol of Religious Freedom

Created by sculptor Coert Steynberg, the central figure – a female with a Bible in her right hand and a broken chain in her left hand – symbolises the spirit of religious freedom. The fleur-de-lis on her dress denotes nobility of character. Casting off the mantle of oppression, she stands on top of the globe – spiritually free, gazing into the future.

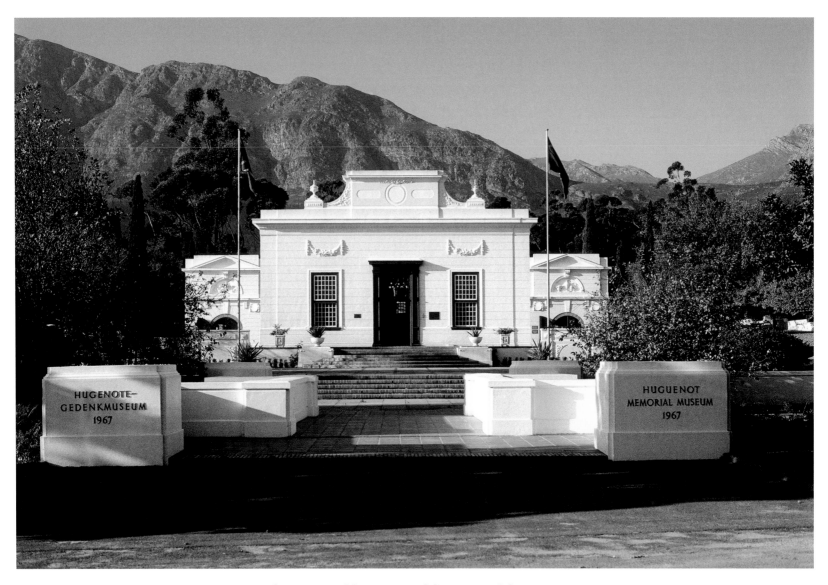

SAASVELD, HUGUENOT MEMORIAL MUSEUM

This magnificent building housing the Huguenot Memorial Museum serves as a research, information and education centre on the Huguenots. The building's neoclassical architecture closely follows that of the elegant historical Saasveld residence built in 1791 on the estate of Baron Wilhelm Ferdinand van Rheede van Oudtshoorn in Cape Town. The building was demolished in 1954. The original building was designed by Louis Michel Thibault, a student of the famous Ange-Jacques Gabriel at the Académie Royale d'Architecture in Paris. The decorations are thought to have been done by German sculptor Anton Anreith who came to the Cape in 1777.

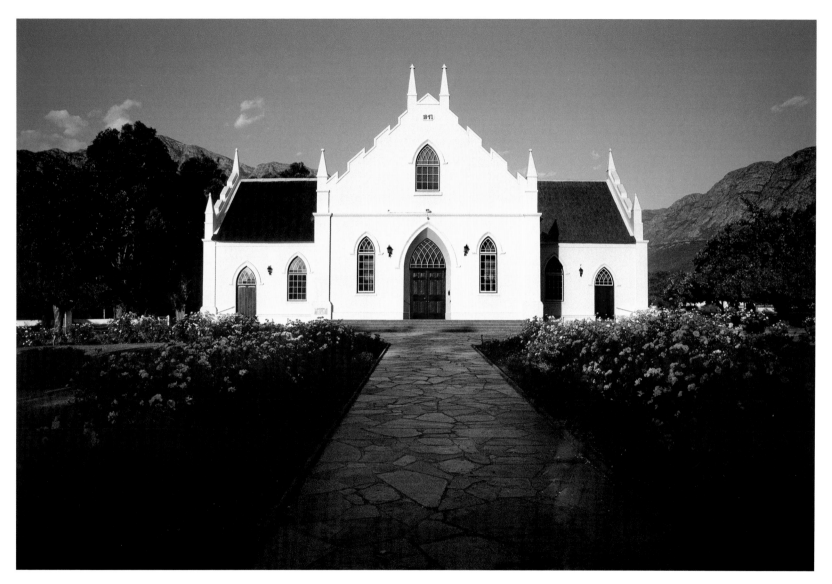

Dutch Reformed Church

This distinctive Dutch Reformed Church was built in the neo-Gothic style in 1847. It evolved from a simple structure, eighty-four feet long, thirty-six feet wide and seventeen feet high. It had a rye-thatched roof and no spire. A bell tower was erected in 1855 after much acrimonious debate as to its location. The addition of two wings in 1882–83 enlarged the church and gave it its present Greek cross formation. The beautiful little church on Huguenot Street is a heritage site.

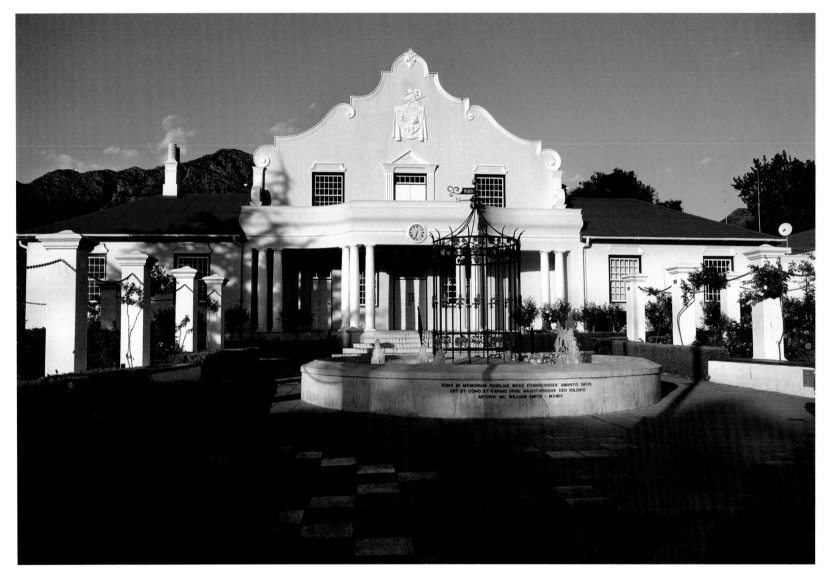

FRANSCHHOEK TOWN HALL

Built in 1935, this single-storey oblong building with its red corrugated roof has an elaborate central gable with a door and windows which open onto a balcony supported by concrete columns. In the middle of the gable is the old municipal crest featuring the blushing bride protea flower (*Serruria florida*), known as the 'Pride of Franschhoek', a cornucopia, an elephant (a reference to the valley's original name, Oliphantshoek), the Franschhoek mountains, and a Huguenot with a flamboyant wide-brimmed, plumed hat. The motto on the scroll is *Dieu et mon droit* (God at my right hand). In front of the building is a rose garden and a fountain flanked by whitewashed pillars.

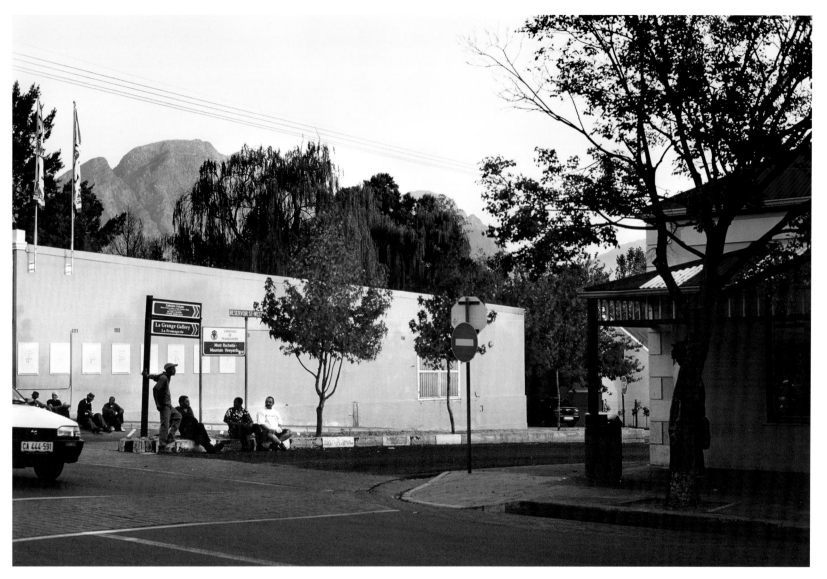

ISLAND IN THE SUN

The central traffic island on the corner of Huguenot Street and Reservoir Street-West is a favourite place for farm workers to sit and relax and have a chat after a good day's work.

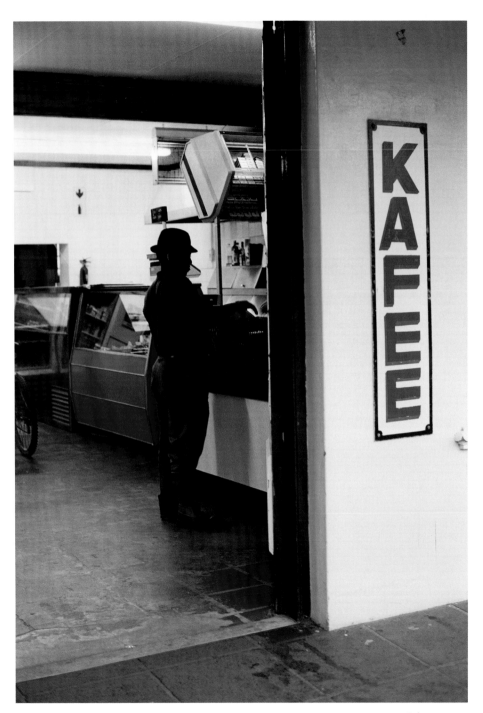

THE UBIQUITOUS CAFÉ

Every little town in South Africa has a café where basic provisions can be conveniently purchased. These establishments typically sell milk, bread, sugar, sweets, chocolates, cigarettes, newspapers, tinned foods, and fast-food take-aways.

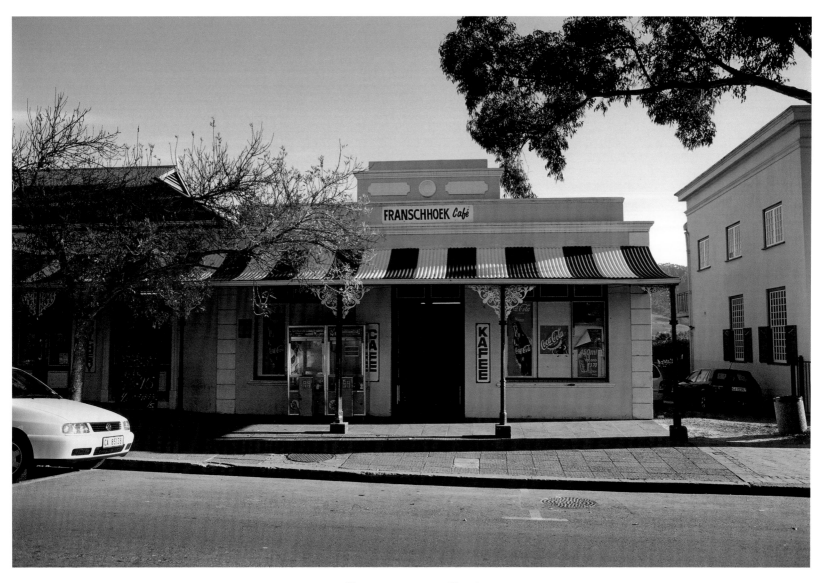

FRANSCHHOEK CAFÉ

The Franschhoek Café, a refurbished Victorian building, is a popular meeting place for locals, especially farm workers, when they come to town.

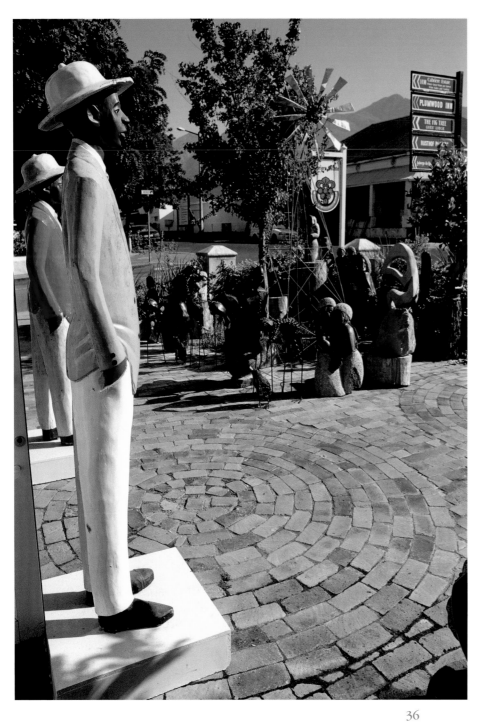

CULTURAL FUSION

Nowadays visitors from other countries on the African continent visit South Africa in ever-growing numbers, adding spice to the cultural mix. These well-attired curios with a somewhat sophisticated air stand sentinel outside the door of a shop on Huguenot Street.

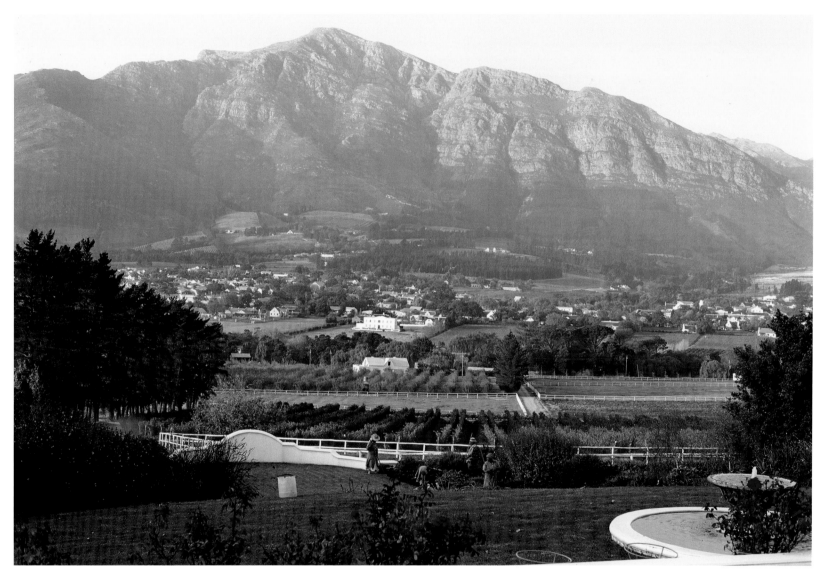

MONT ROCHELLE MOUNTAIN VINEYARDS

The magnificent Mont Rochelle Mountain Vineyards has a majestic view over the Franschhoek Valley and the Wemmershoek mountains.

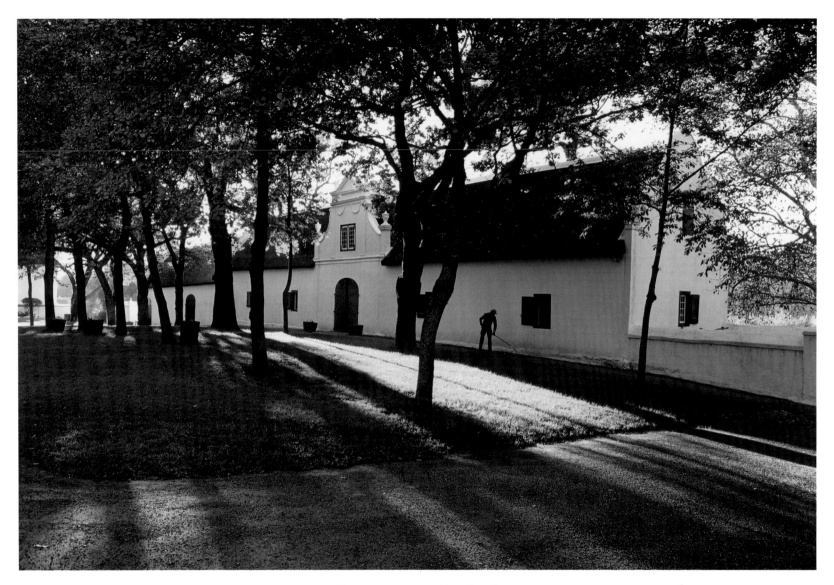

BOSCHENDAL – LE CAFÉ

Le Café, once the slave quarters of Boschendal, is an excellent place for an unhurried lunch or tea, especially when sitting outside in the dappled shade of the spreading oak trees enjoying the unique Cape Dutch architecture.

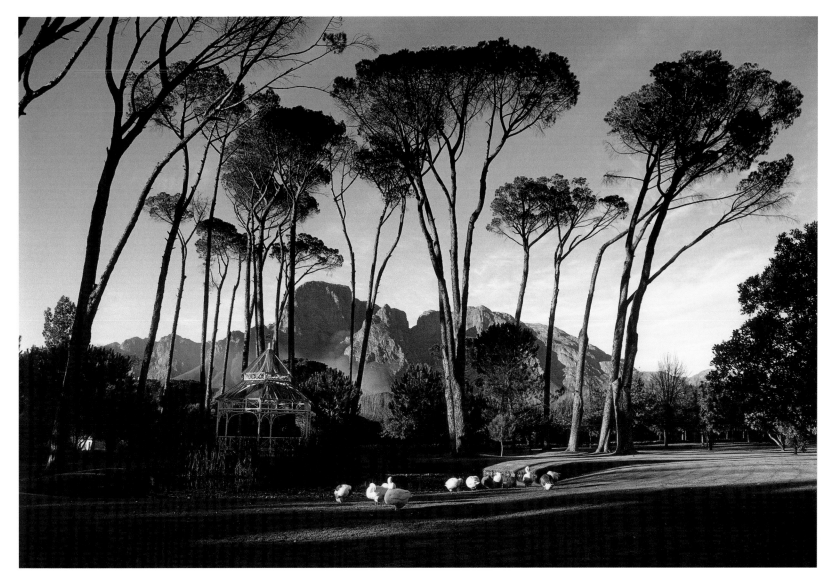

BOSCHENDAL

The majestic Groot Drakenstein mountains, towering, fragrant pine trees, a gazebo, a duck pond and verdant manicured lawns bathed in early morning sunshine – anyone for *le pique-nique*? Boschendal provides elegant French-style picnic fare during the summer months.

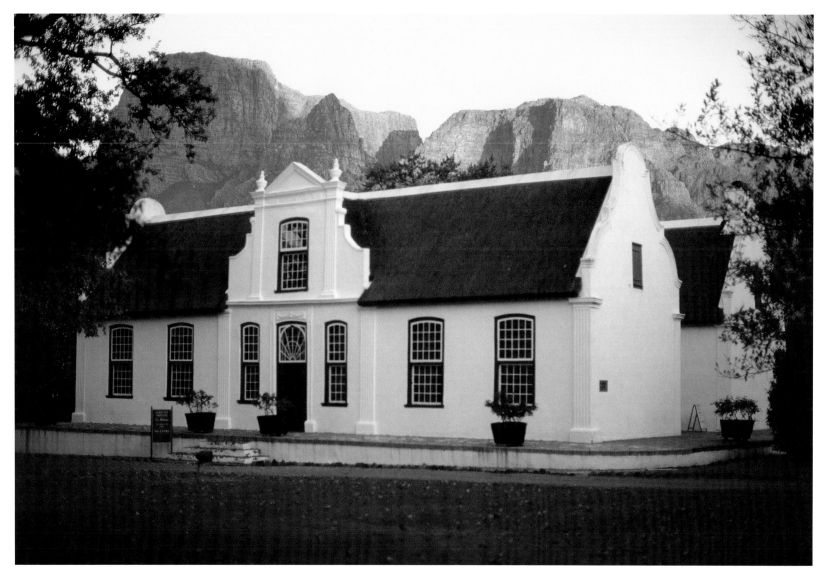

LE RHONE MANOR HOUSE

The magnificent Le Rhone Manor House is offset by the towering grandeur of the surrounding mountains at dusk.

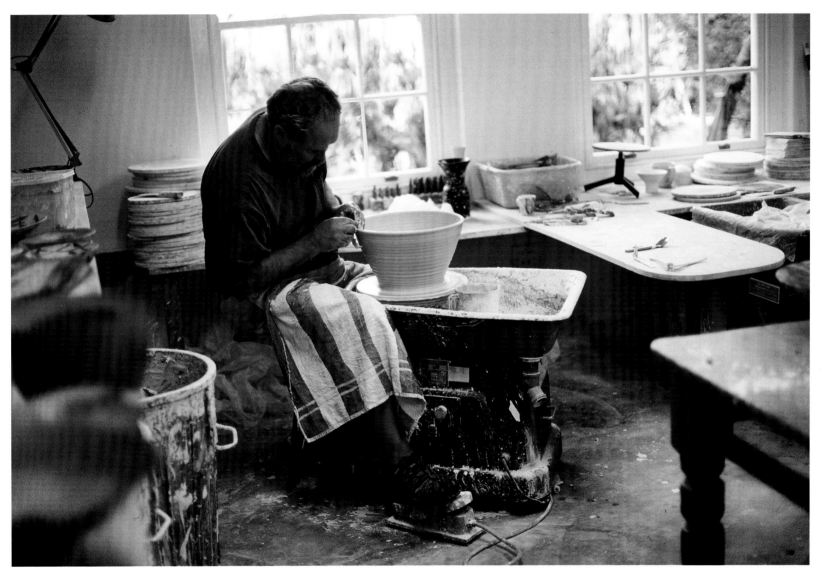

Master Potters

David Walters is one of South Africa's most distinguished potters. He and his wife, Michelle, live and work in Franschhoek, adding to the unique cultural mosaic of this Cape country village. David specialises in hand-thrown, reduction-fired fine porcelain and smoke-fired porcelain with gold-leaf decoration.

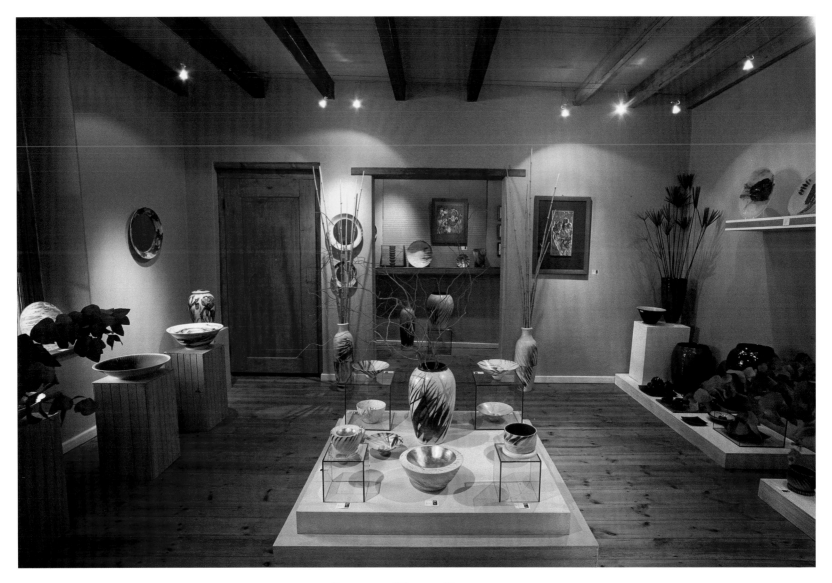

ROUBAIX HOUSE GALLERY

David Walters' works are subtly African, functional and eminently collectable. His Roubaix House Gallery, once a derelict Victorian mansion, was also the home of Franschhoek's first teacher. Restored to its former glory, the building incorporates several showrooms, a studio and the Walters' home.

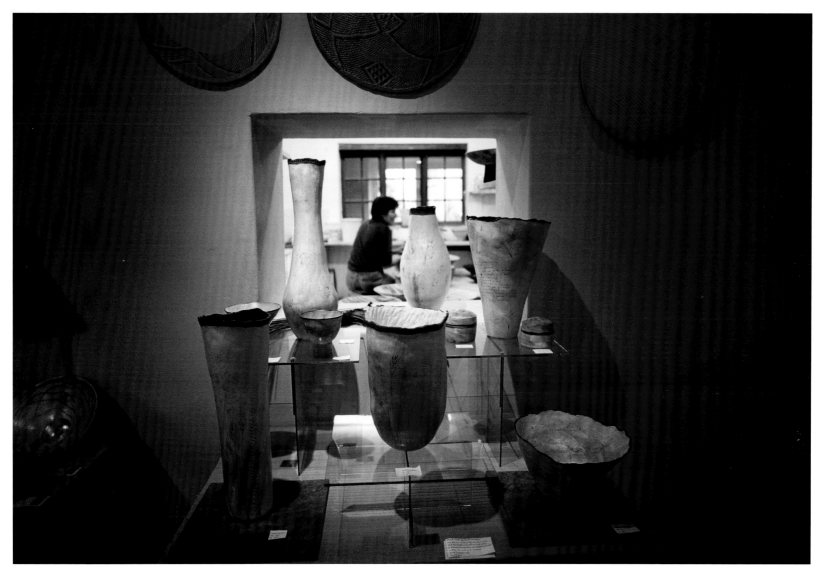

POTTERS' CONTINUITY

The beautiful pots seen here are the work of Sarah, the daughter of Franschhoek potters, David and Michelle Walters, who shares her parents passion for pottery.

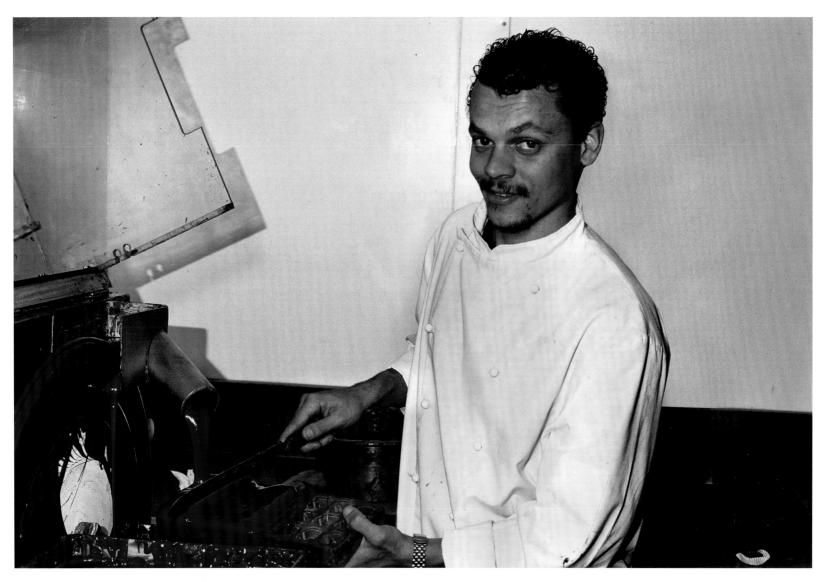

BOUTIQUE CHOCOLATIERS

Huguenot Fine Chocolates, a little factory and shop, is the home of Franschhoek's very own boutique chocolatiers. A visit to this establishment is simply delightful. Molten golden-brown chocolate continuously pouring from a small machine in a temperature-controlled environment sets the scene. Visitors can observe the chocolate-making process through a large glass panel. Here, chocolatier Denver Adonis skilfully fills his moulds with heavenly chocolate.

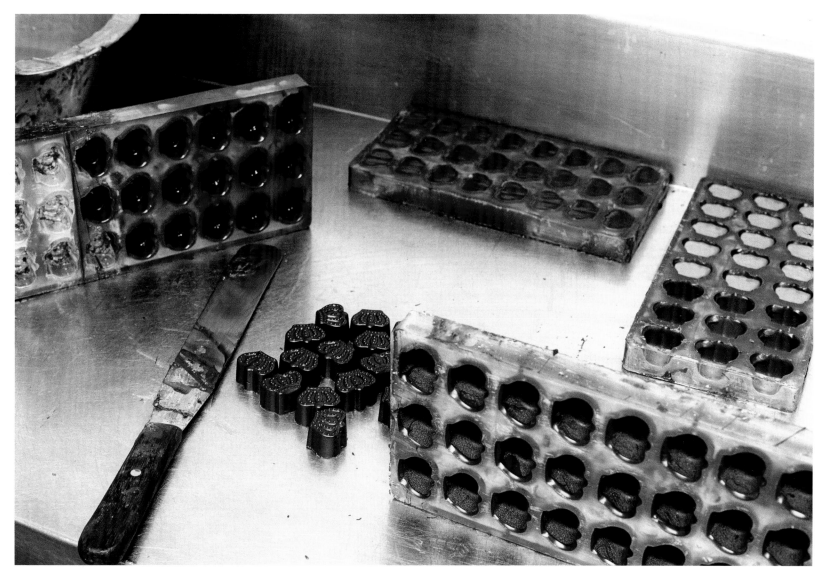

Chocolate Heaven

The rich aroma of chocolate and the imaginatively packaged presentation boxes behind the counter are bound to transform the most disciplined dieter into a chocoholic. Denver Adonis and Danny Windvogel, the owners of Huguenot Fine Chocolates, are local men who, as part of an empowerment project, were sent to Belgium by the Belgian government to train as chocolatiers in 1997. Their selection of fine chocolates includes walnut, marzipan, kirsch crème, coffee, pistachio and South African liqueurs. They use imported Belgian chocolate which has a high cocoa butter content. Says Denver: 'You can taste the difference.'

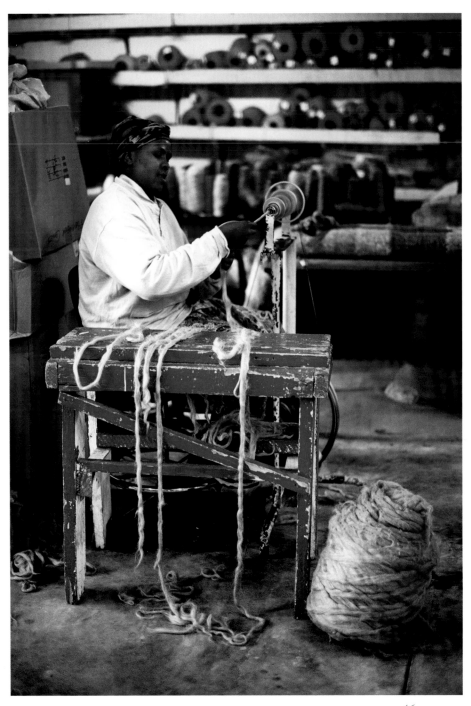

KEI CARPETS

At Le Mouillage farm in the Franschhoek Valley, Xhosa weavers, using the ancient time-honoured Ghiordes knot, produce superb hand-crafted Kei carpets. The carpets have up to 40,000 knots and weigh about six and a half kilograms per square metre. Hand-spun Pure New Wool, available in 180 different colours, is used to create the treasured rugs.

WORKS OF ART

The designs and colours of the unique hand-knotted Kei Carpets reflect the vibrancy and diversity of the African continent. Commissions by discerning clients for one-off designs are undertaken.

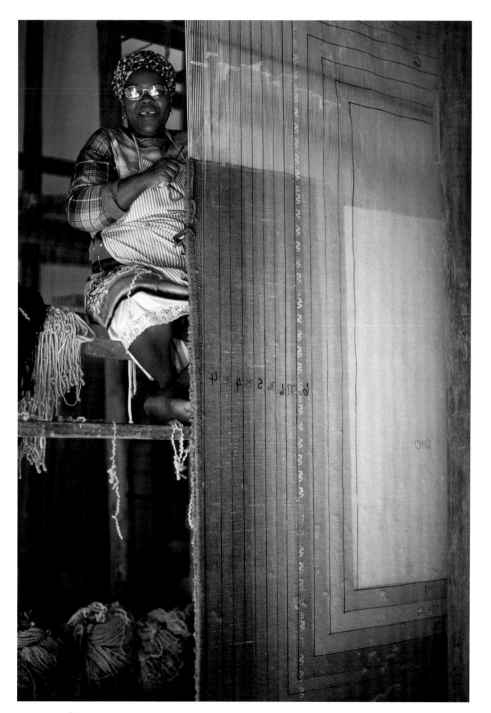

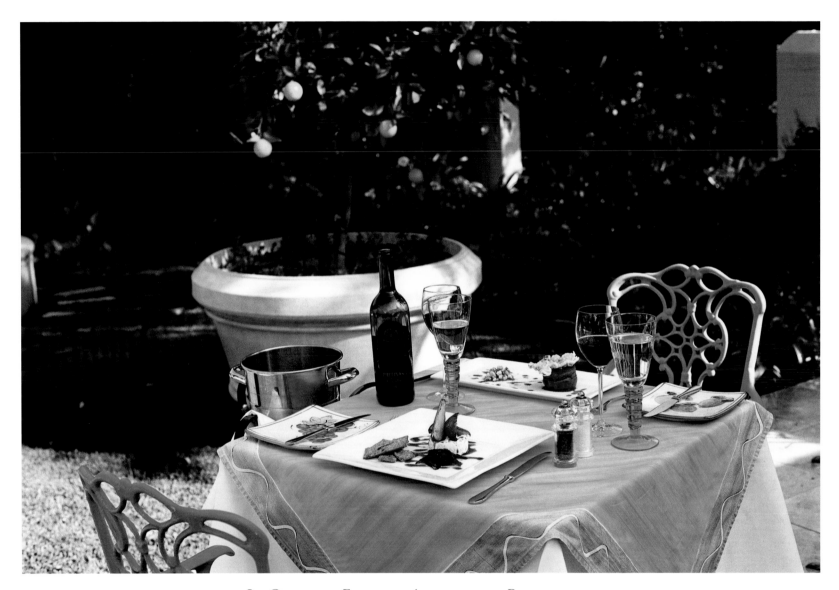

LE QUARTIER FRANÇAIS AUBERGE AND RESTAURANT

Franschhoek's Le Quartier Français is synonymous with excellence. This award-winning auberge and restaurant, famous for its Gallic flair, is situated in the heart of the gourmet capital of the Cape. A member of the Relais & Chateaux association, the establishment is owned by Susan Huxter and expertly managed by Linda Coltart. Popular menu items include Dalewood capricious camembert with roasted pear, greens and red wine syrup (front) and double baked beetroot and rocket soufflé with apple and hazelnut (back).

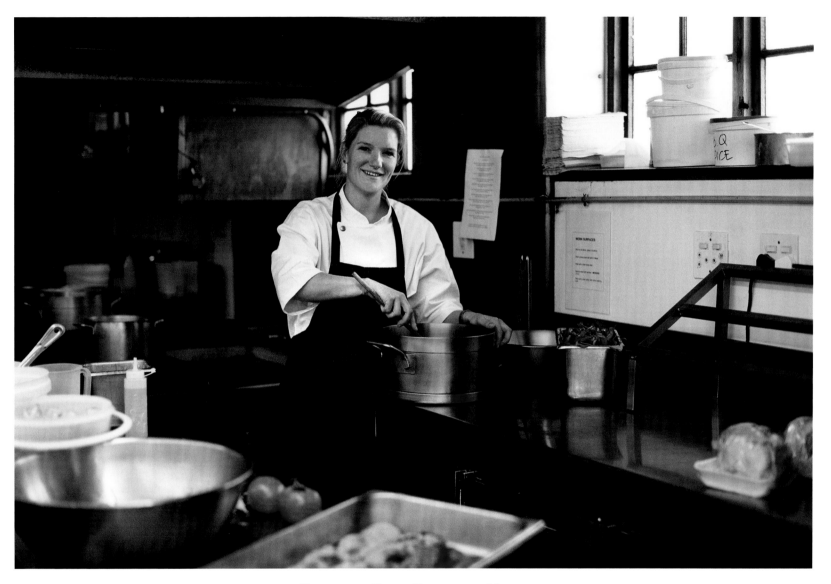

CREATING FOOD FROM THE HEART

Margot Janse, the award-winning executive chef of Le Quartier Français, is an exponent of inspired culinary art. A delightful personality, she cooks with passion, simplicity and flair, using only the best Cape produce, and pays meticulous attention to detail and presentation in her restaurant.

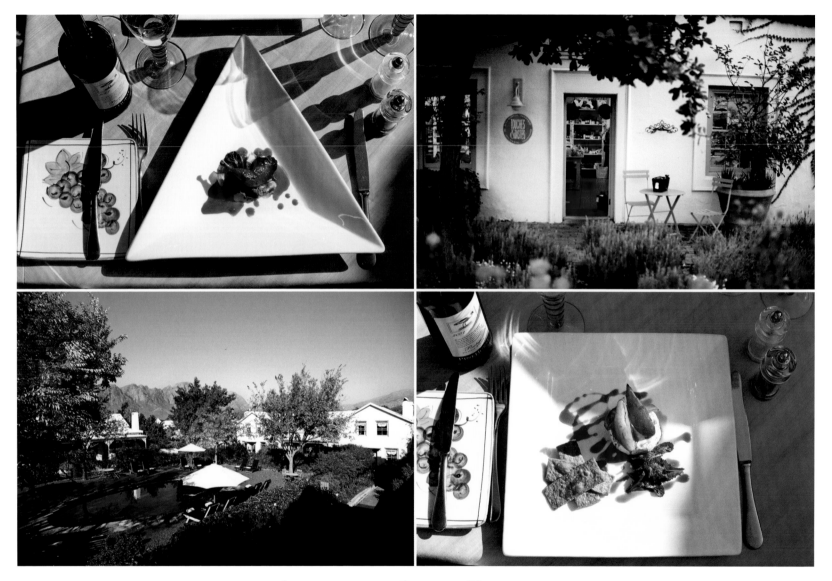

AWARD-WINNING COUNTRY HOSPITALITY

Le Quartier Français has fifteen luxurious en-suite bedrooms and two executive suites which overlook a private garden. The establishment has garnered an impressive list of accolades, including Chef of the Year, awarded to executive chef Margo Janse by *Eat Out* in 2003. Also in 2003, *Wine* magazine voted Le Quartier Français one of South Africa's top 100 restaurants. In 2002 the *Daily Telegraph* voted the auberge the best hotel of the year. With sublime dishes such as cured quail with zucchini and parmesan salad (top left) and Dalewood capricious camembert with roasted pear (bottom right), it comes as no surprise that Le Quartier Français was rated among the world's top fifty restaurants in 2002.

SAVOURING LOCAL CHEESES

La Fromagerie at La Grange is a restaurant in Franschhoek where cheese tastings are held and where one can buy a wide variety of local cheeses. La Grange overlooks vineyards and hills and offers spectacular mountain views. Here one can share a specially selected bottle of Franschhoek wine and an inspiring choice of local cheeses amid the breathtaking scenery of the valley – yet another Franschhoek experience not to be missed.

The famous cheese company, Truckles Traditional Cheese, and the cheese restaurant, La Fromagerie at La Grange, are owned by the Blaissè family who originate from the Netherlands. Local cheeses are generally made in the traditions of European countries such as Holland, Italy, England and France. Naturally no flavour enhancers, artificial colouring or preservatives are used.

South African cheese-making has blossomed over the last decade and should excite the most discerning of palates.

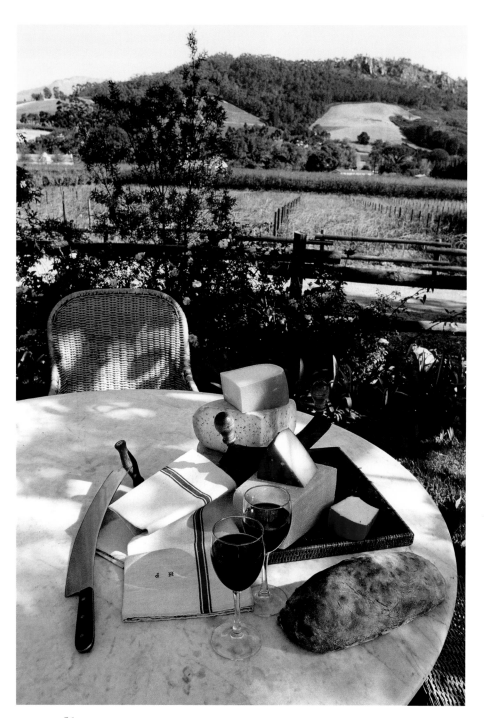

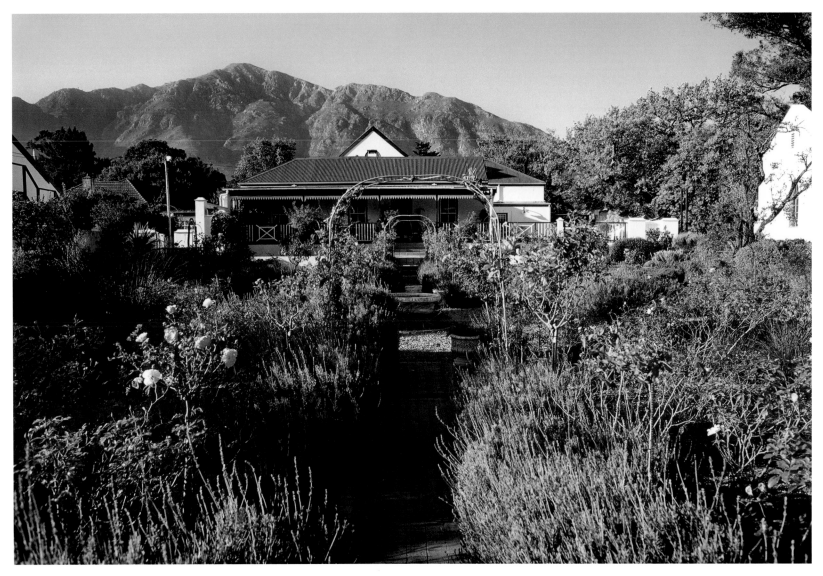

RÉSIDENCE KLEIN OLIPHANTS HOEK

A short stroll from the heart of the village, Résidence Klein Oliphants Hoek (Little Elephant's Corner) is a fine example of stylish living amidst mountains and vineyards.

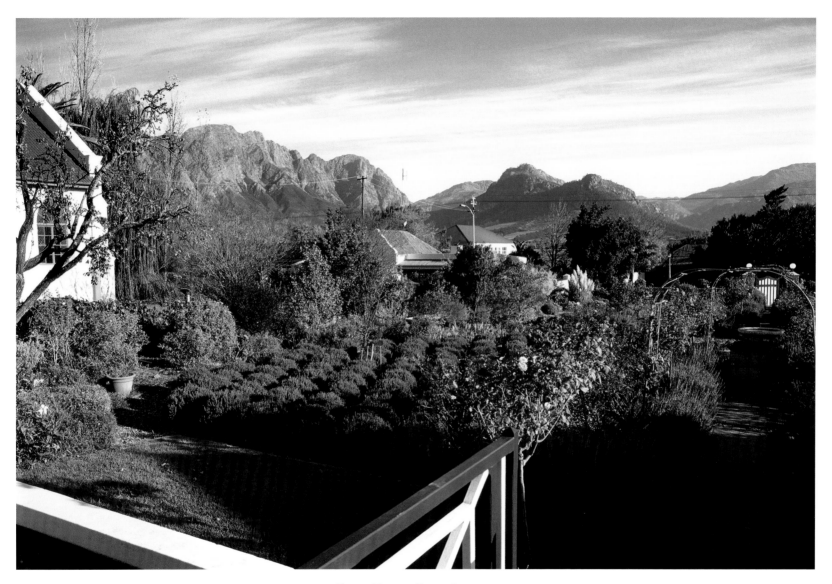

Fine Fare, Fine Living

Tranquillity amid spectacular surroundings, the lovely fragrances of a herbaceous country garden, and a long drink on a Victorian veranda are perfect accompaniments to fine fare, congenial company and old-world ambience.

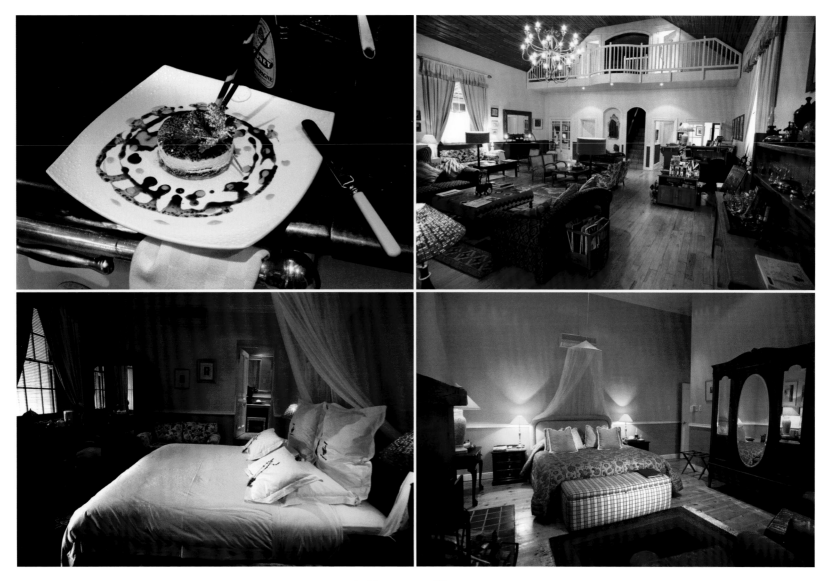

A Country Haven

Once used as a chapel, Klein Oliphants Hoek was built in 1888 by the English missionary, Reverend Lloyd. In the century that followed, it housed a school and then a theatre before being transformed into an elegant country haven to delight even the most fastidious connoisseurs of fine living. Mouth-watering desserts, such as tiramisu dressed with raspberry sauce, coffee syrup and drizzled with honey from the region (top left), are created in the open kitchen of Résidence Klein Oliphants Hoek, where most of the cooking is done on an old wood-burning stove.

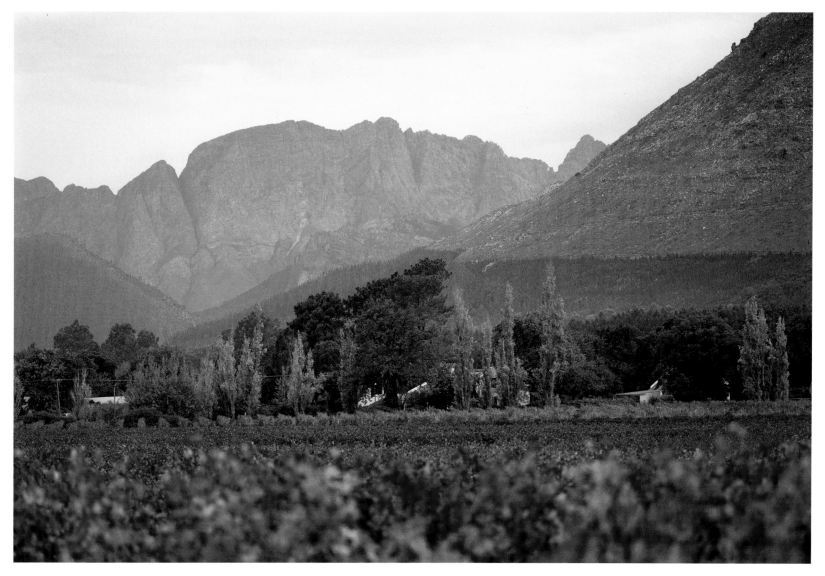

THE ART OF WINE-MAKING

Creating wines of distinction is a science and an art, and the result of an affinity with nature, a love of the earth, and the sensitivity to celebrate its bounty.

LA PETITE FERME

A visit to La Petite Ferme (The Little Farm) is a rather special experience. Situated in the mountains high above Franschhoek, it is a must for *cognoscenti* of lunchtime dining and for romantics who will find the view, the ambience and the wine perfect accompaniments to the superb food on offer. The estate is owned by the extended Dendy Young family. Carol Dendy Young assists resident chef Olivia Mitchell in the kitchen, where they collaborate on creating memorable gastronomic delights such as this dish of pear and prunes in Pinotage, infused with cinnamon, orange and lemon zest with a dollop of vanilla.

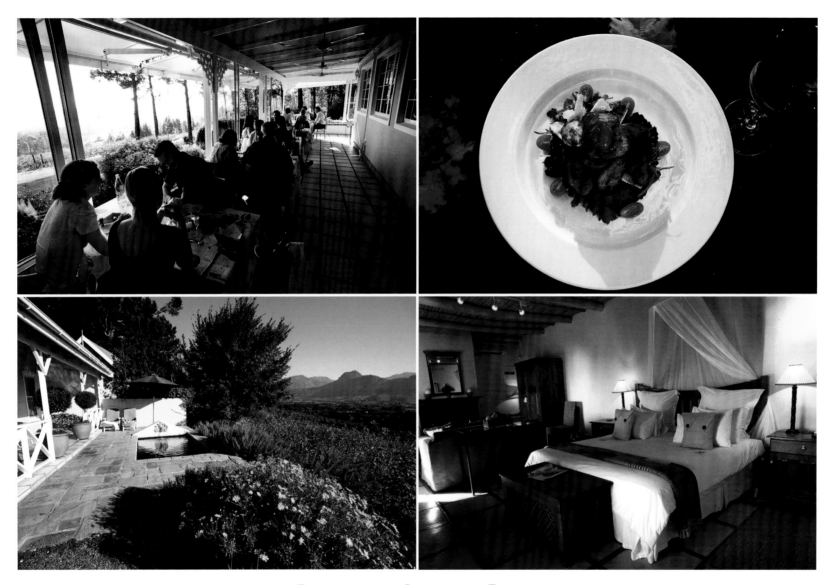

EXCELLENCE IN LUNCHTIME DINING

The abundance of pure mountain air, sun-drenched vineyards and towering mountains, combined with delicious country cooking, make La Petite Ferme a favourite dining destination in the Cape Winelands. Here one is warmly greeted and pampered by members of the charming Dendy Young family, associated with the farm for three generations. The cuisine is best described as French with local and Cape Malay influences, and the recipes have been passed down through the generations. Only the freshest ingredients, including herbs grown on the farm, are used. The Dendy Youngs also run luxurious guest suites on the farm, each with a private patio and plunge pool.

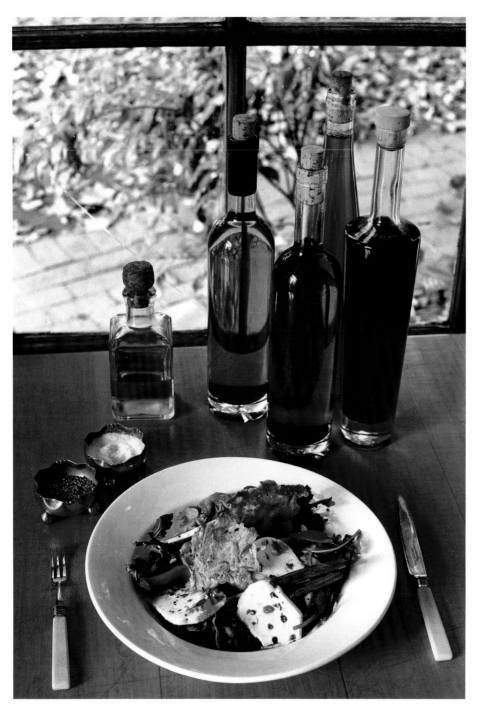

CULINARY GEMS

Topsi & Company, just off the main street, is another of Franschhoek's delightful restaurants. Here Topsi Venter, an internationally renowned and respected South African cook, often personally serves her appreciative diners. The highly original menu, which includes culinary gems such as this goat's cheese trio, is chalked up on a large blackboard and changes almost daily.

The Kitchen at Topsi & Company

The ambience at Topsi & Company is warm, unhurried and friendly. Diners can watch their food being lovingly prepared in an open-plan kitchen adjoining the restaurant.

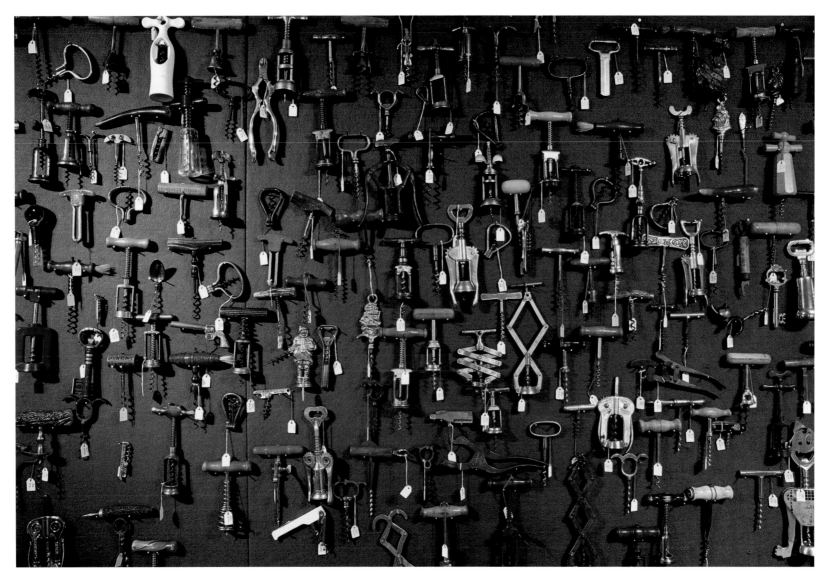

THE OLD CORKSCREW

The essential accoutrements of the wine connoisseur, ranging from antiques to modern utilitarian gadgets, can be purchased in a rather delightful specialty shop called The Old Corkscrew. Believed to have the largest selection of corkscrews in Africa, the shop has approximately 500 different corkscrews in stock at any one time. They date from 1750 to 1970. Among the most expensive corkscrews are the magnificent brass bar cork drawers and some Georgian silver items. Other accessories, such as wine coolers, coasters and tastevins, are hard to resist. Antiques on offer include Art Nouveau, Art Deco, porcelain, glass and pewter items. The shop claims to have the most extensive silver collection in South Africa.

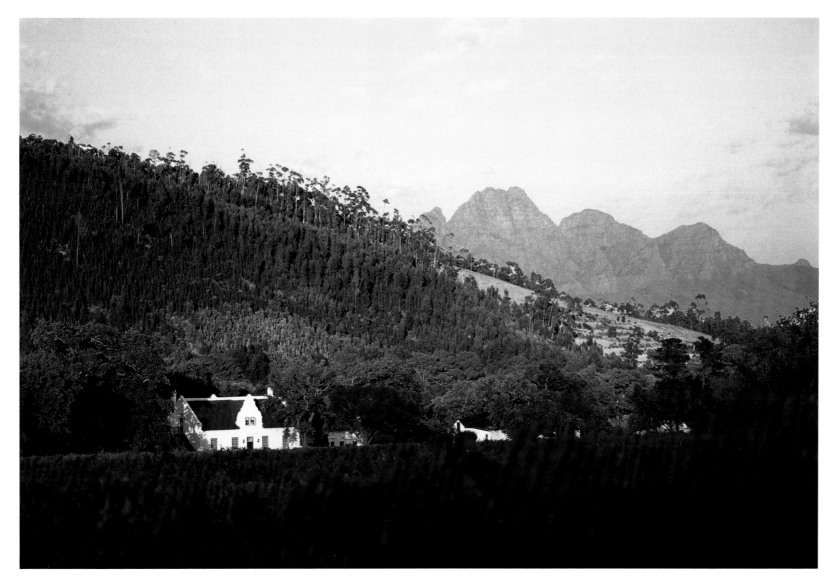

Basse Provence

The Cape Dutch homestead on the farm Basse Provence is a fine sight. It was part of the farm La Provence, one of the original ten farms founded in the Franschhoek Valley in 1694. The farm was subdivided for the first time in 1842. The manor house and wine cellar were built in 1855. In 1997 the Jonkershuis was transformed into a four-bedroomed luxury guesthouse. It is a fine blend of traditional Huguenot heritage and South African culture. The name Basse Provence (Lower Provence) was chosen by a former owner, Theo Lotter, to differentiate the estate from other establishments in the area called La Provence.

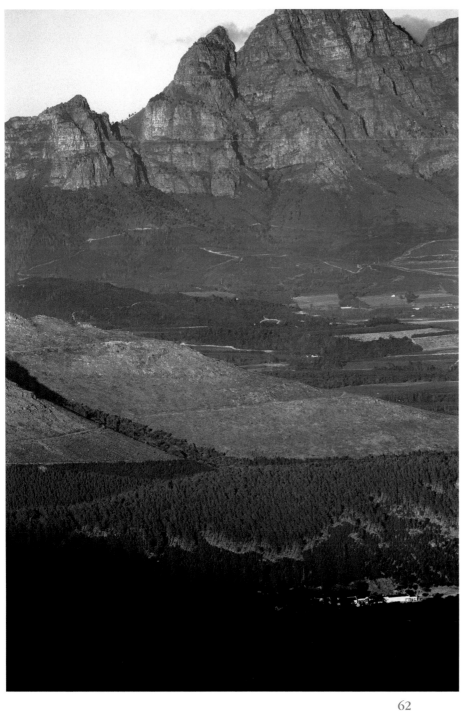

DAWN IN THE FRANSCHHOEK VALLEY

The Franschhoek mountains are illuminated at dawn by the early rays of the sun which slowly creep down the mountain to highlight Rickety Bridge Winery, before bathing the rest of the Franschhoek Valley in glorious sunshine.

Rickety Bridge Winery –
A Place of Excellence

Rickety Bridge Winery proudly displays the Vignerons de Franschhoek signage, a badge that is synonymous with viticultural excellence in this unique and historic corner of the Cape Winelands. Franschhoek is one of the oldest wine-producing regions in the New World with a tradition of fine wine-making that dates back to 1694.

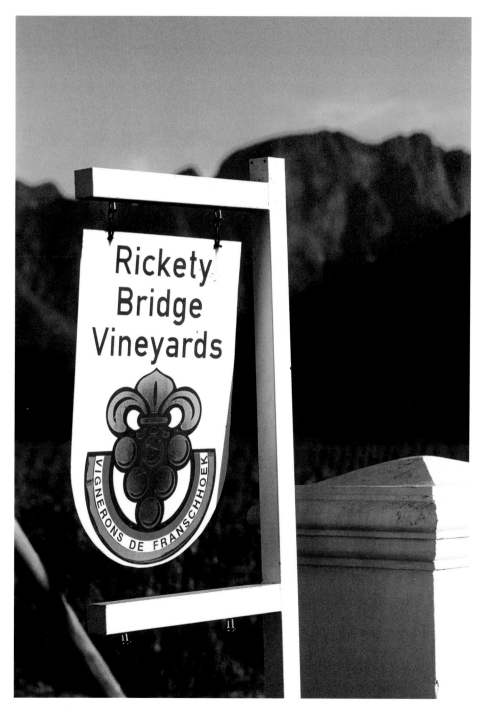

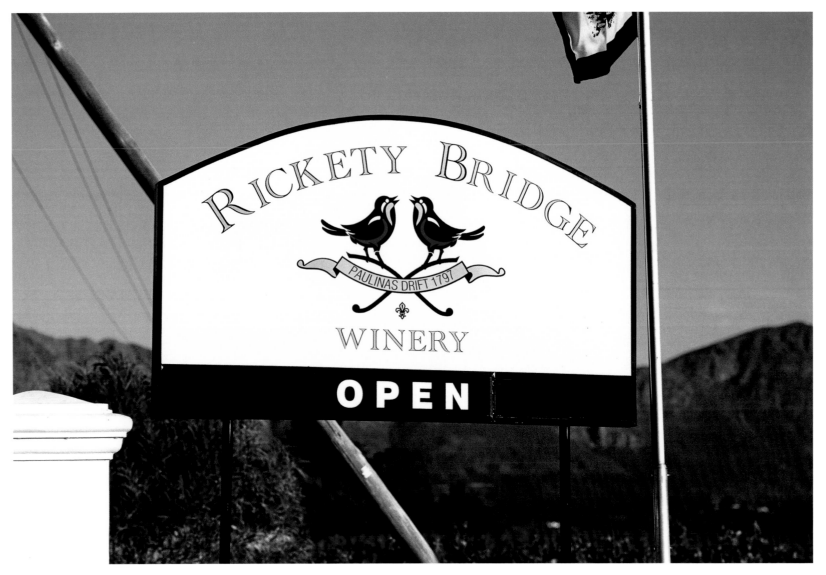

RICKETY BRIDGE WINERY

The welcoming Rickety Bridge Winery signboard features a pair of robins, perched on stylised twigs. A scroll bears the inscription 'Paulinas Drift 1797'. Below it is a fleur-de-lis. Nearby, a flutter of flags heralds the arrival of visitors. The flags bear the names of some of the estate's famous wines, for example Duncan's Creek White, an unwooded wine of distinction named after the winery's owner, Duncan Spence.

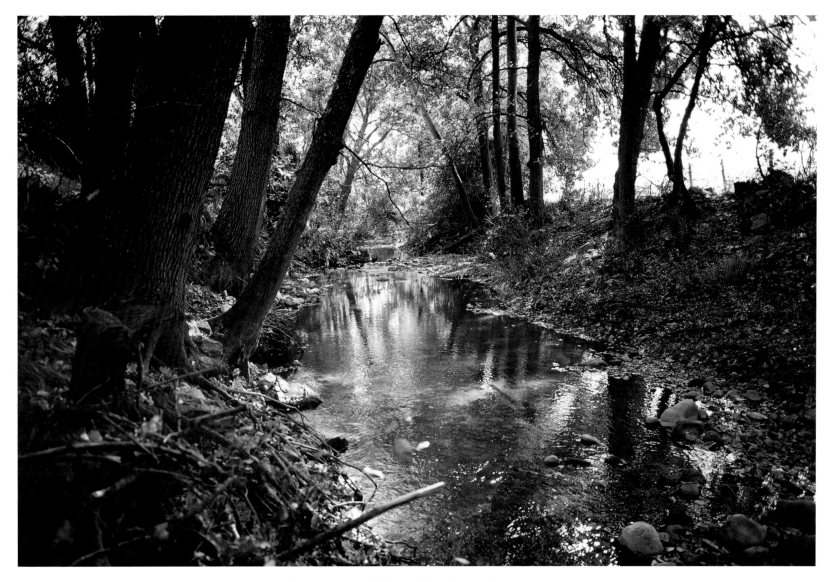

THE BRIDGE THAT WAS ONCE RICKETY

The little bridge that once crossed the Franschhoek River to provide access to the farm on the other side was, as the name suggests, indeed rickety. It mainly consisted of narrow wooden sleepers which straddled the river near to where this photograph was taken. Later, heavy vehicles were obliged to drive through neighbouring farms via an old public road, built in the 1800s, which passed directly in front of the manor house. The present concrete bridge was built in 1996. The name Rickety Bridge Winery is synonymous with robust, award-winning wines which, like the old bridge that once spanned this river, link time-honoured French wine-making traditions with the advances of viticulture in the twenty-first century.

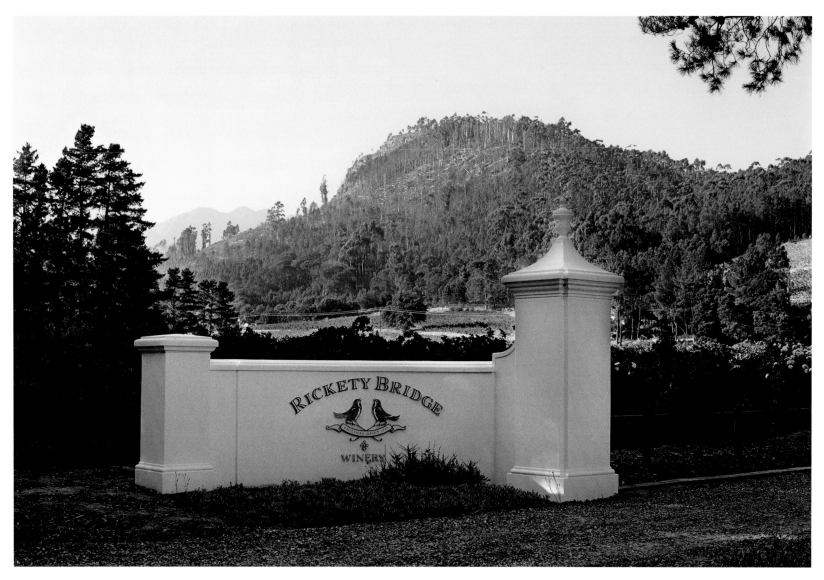

Variety – The Spice of Life

Rickety Bridge Winery's cellar has the capacity to handle 200 tons of grapes per year. The vineyards are currently planted with the following cultivars: Cabernet Franc (0.42 hectares), Cabernet Sauvignon (3.88 hectares), Shiraz (1.63 hectares), Chardonnay (1.85 hectares), Chenin Blanc (1.48 hectares), Malbec (0.17 hectares), Merlot (1.6 hectares), Sauvignon Blanc (1.01 hectares) and Semillon (0.8 hectares).

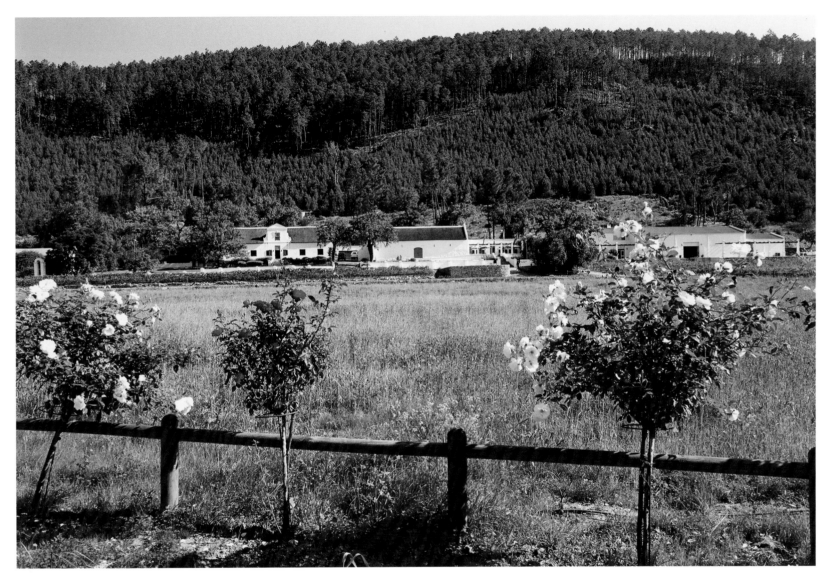

RICKETY BRIDGE VINEYARDS AND WINERY

The vineyards of the Rickety Bridge estate were originally part of the farm La Provence, which was allotted to the French Huguenot Pierre Joubert on 18 October 1694. Seen here, from left to right, are the slave bell, the gabled manor house, the old wine cellar, the wine-tasting centre, the administration offices and the winery.

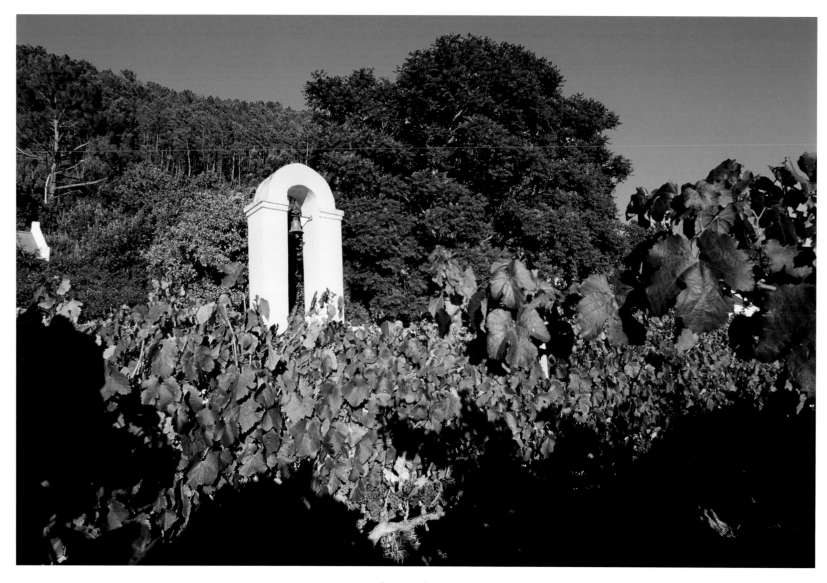

SLAVE BELL

The slave bell at Rickety Bridge Winery stands as a silent reminder of a time when slavery was widely practiced in the Cape. In 1658 Jan van Riebeeck imported the first slaves, mainly from Asia, to meet the labour needs of the small Dutch settlement at the Cape. The Huguenot farmers made use of imported slaves, buying them from the Dutch East India Company or from other farmers at auctions. Slaves often represented a farmer's greatest assets. However, they were not always good workers, as they were sometimes inebriated, fought among each other, stole or absconded. Many slaves died in smallpox and measles epidemics. Slavery was abolished in 1833.

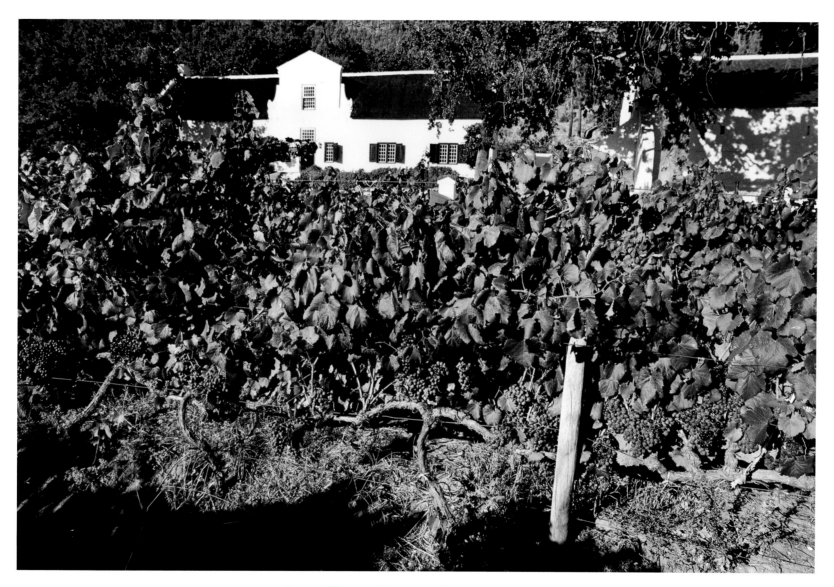

LAND USE AT RICKETY BRIDGE WINERY

The 50.56-hectare Rickety Bridge Winery is positioned next to the Berg River and nestles against the Dassenberg hill. The vineyards cover 12.84 hectares of the farm, while mountainous areas constitute 30.87 hectares. Buildings and dams make up 0.69 hectares. Sections of the remaining 6.16 hectares of fallow land have been earmarked for future development.

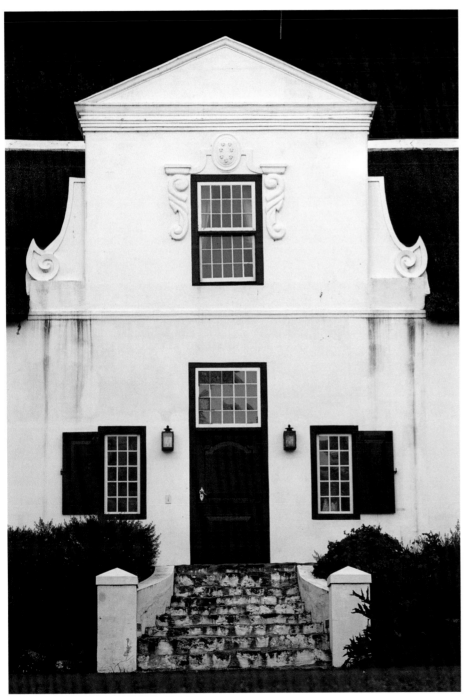

RICKETY BRIDGE WINERY MANOR HOUSE

The Rickety Bridge Winery Manor House, adorned with an elegant neoclassical gable, was probably built between 1829 and 1831. Designed in the traditional Cape Dutch style, it was restored as faithfully as possible to the original building in 1995 and is a fine example of its kind.

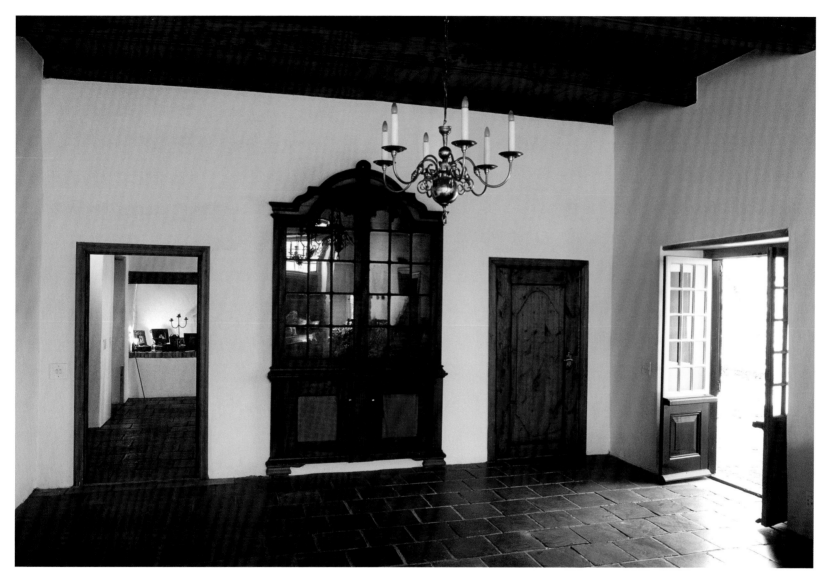

GABLED WALL CUPBOARD

The manor house at Rickety Bridge Winery has an original built-in wall cupboard made from the rare, sought-after indigenous hardwoods, stinkwood and yellowwood. With its curvilinear head and original glass windows, the 170-year-old wall cupboard is one of the finest examples of Cape Dutch furniture.

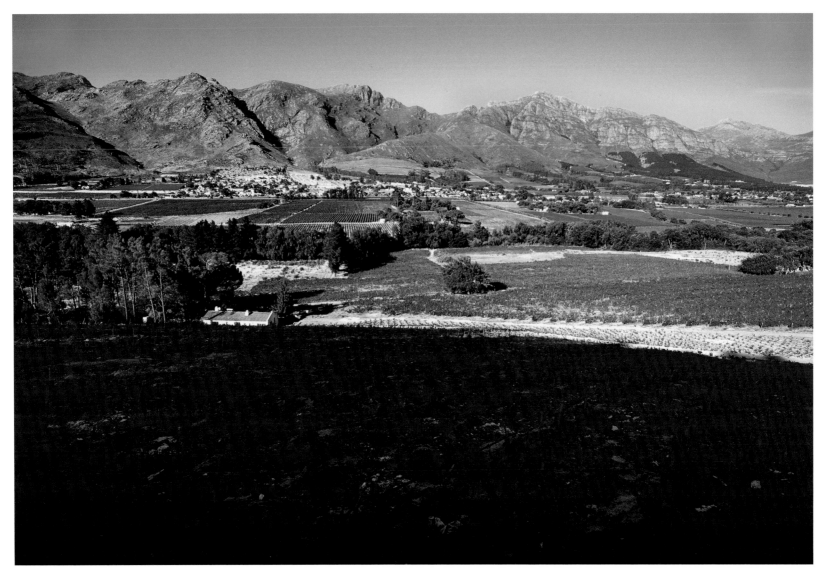

A New Cycle Begins

High on a hillside overlooking the Wemmershoek mountains, the Rickety Bridge vineyards are being prepared for the planting of new vines.

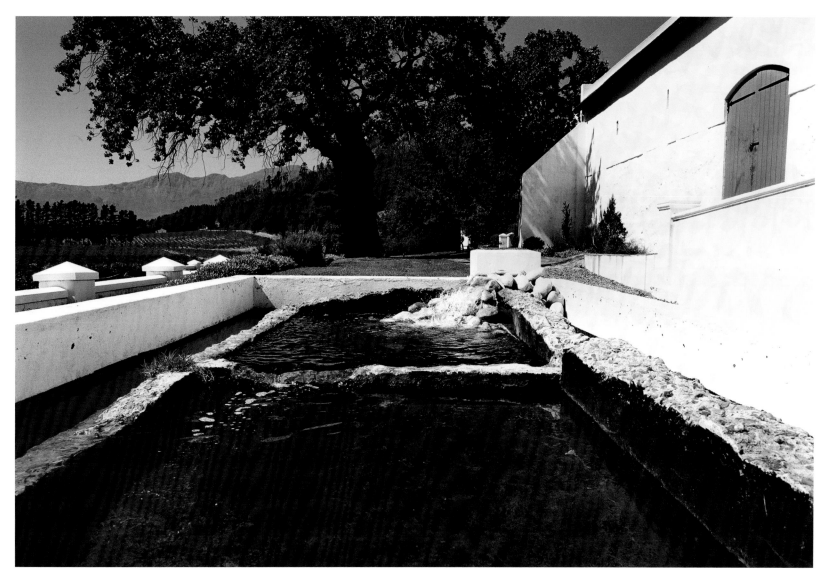

FROM FERMENTATION TANK TO WATER FEATURE

This centuries-old fermentation tank constructed of stones and cement in front of Rickety Bridge Winery's old wine cellar has been preserved as a water feature.

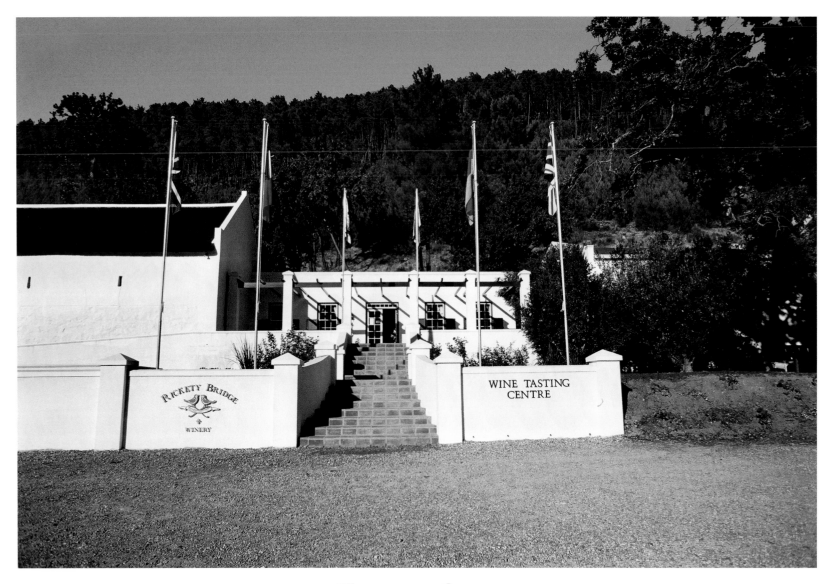

WINE-TASTING CENTRE

The wine-tasting centre at Rickety Bridge Winery is a must for wine *cognoscenti* and a firm favourite among visitors to the Franschhoek Valley.

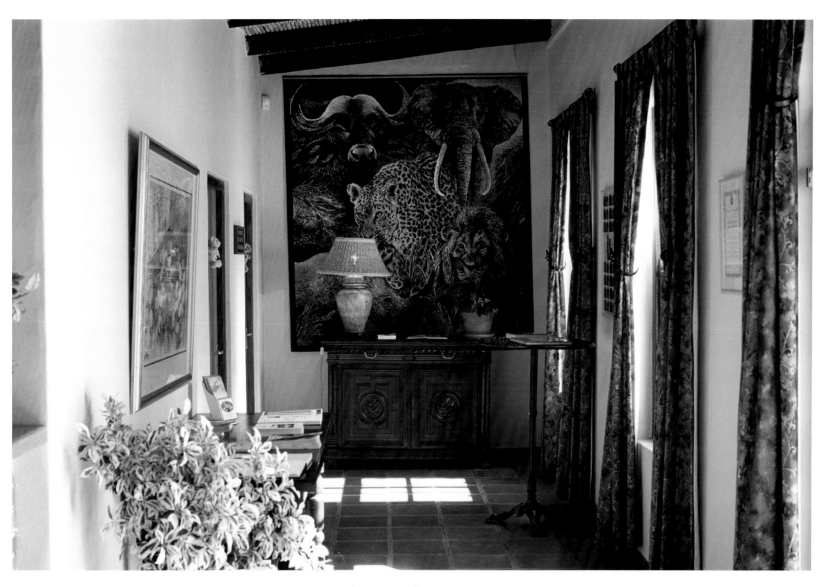

African Ambience

The interior of the wine-tasting centre at Rickety Bridge Winery exudes an elegant African ambience. A large tapestry depicts Africa's big five: the lion, elephant, buffalo, leopard and rhinoceros. Sunlight streaming through the windows adds a warm glow to the scene.

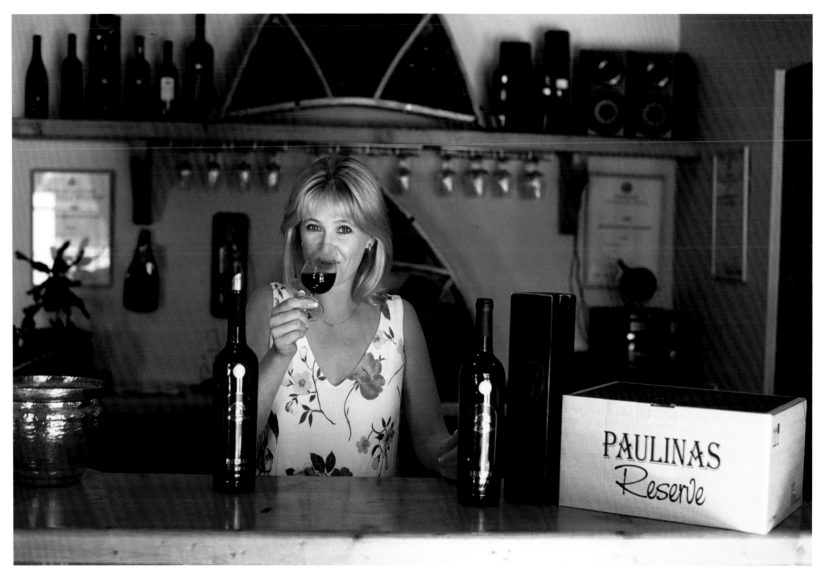

WINE-TASTING

Mariaan Dawson clearly enjoys meeting visitors to the wine-tasting centre at the Rickety Bridge estate. A delightfully sparkling personality, she is passionate and knowledgeable about the wines of Rickety Bridge Winery. Mariaan takes great pleasure in inviting visitors to sample the estate's award-winning wines and discussing the special attributes of each one, all in an atmosphere of warm spontaneity and good cheer.

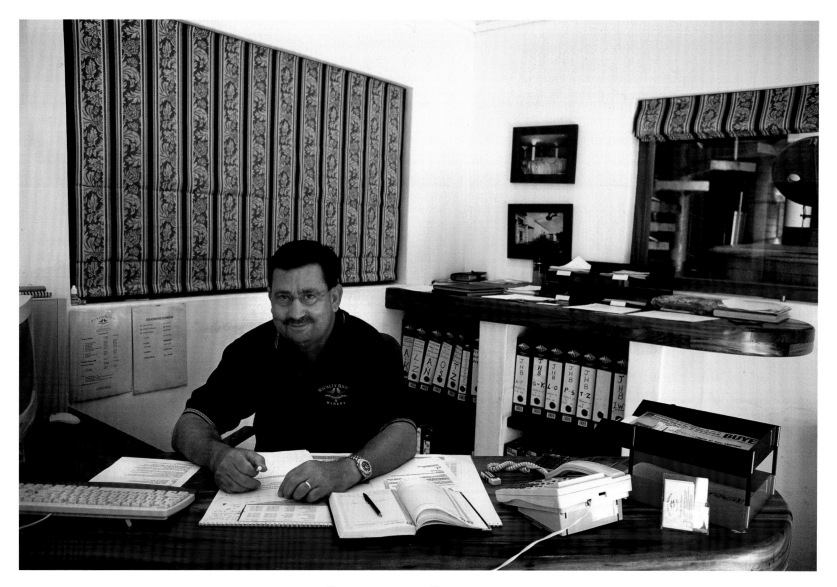

DEDICATED TO EXCELLENCE

Butch McEwan, the general manager of Rickety Bridge Winery, has a wonderful way with his staff, who clearly delight in his ability to communicate with them in their respective mother tongues. His obvious dedication to excellence and pride in the products under his control are evident when one meets him.

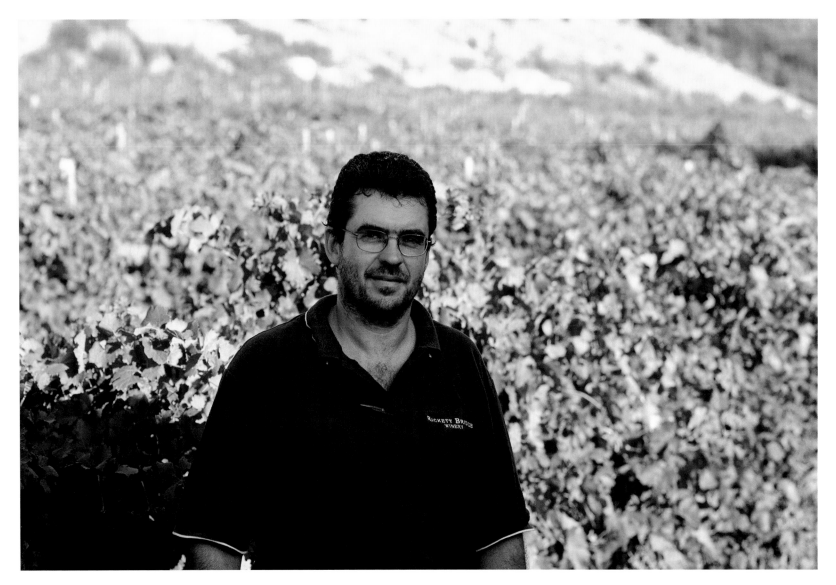

A Man of the Soil

Wilhelm van Rooyen, Rickety Bridge Winery's accomplished winemaker, was a medical doctor who qualified at Stellenbosch University in 1985 and lived and worked in Canada for six years thereafter. A man of the soil and a lover of the South African outdoors, he returned to his alma mater where he completed a Bachelor of Science degree in agriculture, majoring in viticulture and cellar technology. He joined Rickety Bridge Winery in 2001. He prefers making wine in the classical style and pays meticulous attention to detail. Wilhelm's favourite wine is Rickety Bridge Shiraz.

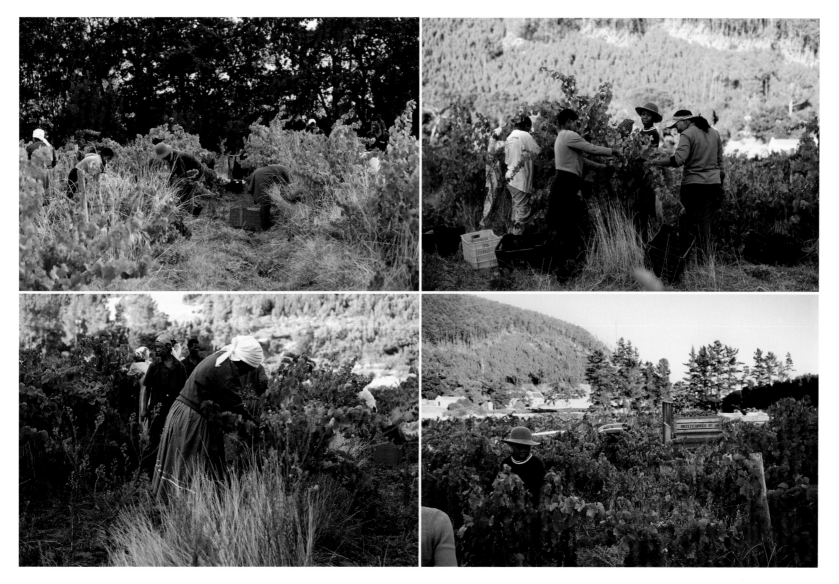

PRECISION HARVESTING

The precise time to harvest grapes is crucial to the quality of the wine, as is pruning practice and the management of the leaf canopy to optimise sun and light penetration. Using the best possible grapes of the harvest goes some way towards producing the finest wines. At Rickety Bridge special attention is given to scientific aspects such as vine density, soil type and the selection of the right cultivars for the right terroirs. The winemaker also concentrates on the acidity, pH level and sugar content of the wine during maturation.

Chardonnay: A spicy and floral wine with lemon, ripe orange citrus and subtle vanilla flavours. Buttery mouth sensation with lingering after-taste. Good acid, fruit and wood flavour balance.

Sauvignon Blanc: A wine with honeydew, melon, paw-paw and nettle (gooseberry) flavours and a long, clean finish.

Semillon: A wine with full, fruity flavours like apricot and peach with Semillon grassiness. Creamy mouth sensation and after-taste. Nutty and herby flavours develop with bottle age.

Cabernet Sauvignon: A full, silky, seamless and rich wine with black fruit and integrated oak flavours.

Merlot: A rich, complex wine with black plum and chocolate flavours.

Shiraz: A meaty wine with violets, black cherry and blackberry fruit, white pepper and spice. Good aging potential.

Pinotage: A meaty and spicy wine with complex red currant and mulberry fruit. Seamless tannins and full, round mouth sensation.

Paulinas Reserve: Tightly packed layers of black fruit flavours with tomato paste. Lingering after-taste and firm tannins.

Duncan's Creek Classic Red: An easy, accessible, fruity wine with sweet, juicy black plum and cassis fruit. Oak flavours fill out the palate.

Duncan's Creek Classic White: An everyday, easy drinking wine with complex tropical fruit and palate-cleansing acid.

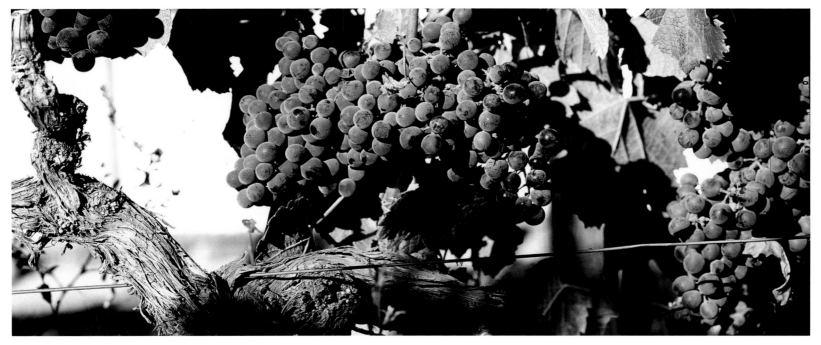

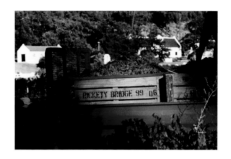

Rickety Bridge Winery – Accolades

Variety	Vintage	Award
Paulinas Reserve	1996	Veritas* Double Gold Award
	2000	Veritas Gold Award
Cabernet Sauvignon	1998	Veritas Bronze Award
	1998	Gold Medal, Air France Top 10, Red Wine Category, Classic Wine Trophy 2001
Shiraz	1996	Veritas Gold Award
	1998	Veritas Gold Award
	1998	Michelangelo Gold Award
	1999	Veritas Gold Award
	2000	Third best in South Africa, Wine magazine
Merlot	1998	Veritas Silver Award
	1998	South African Fairbairn Trophy, Wine Show, Silver Medal
	1999	Veritas Bronze Award
Semillon	1999	Veritas Silver Award
Duncan's Creek Red	2000	Veritas Bronze
	2000	South African Fairbairn Trophy, Wine Show, Bronze Medal
Duncan's Creek White	2000	Veritas Bronze
	2000	South African Fairbairn Trophy, Wine Show, Bronze Medal

Veritas: South African National Bottled Wine Show

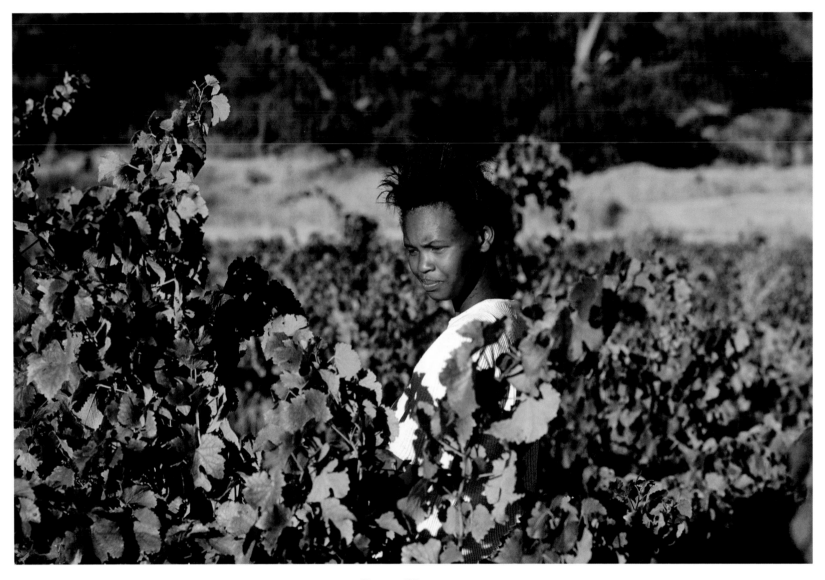

DAWN HARVEST

Alfreda Jacobs basks in the early morning sunshine as she harvests the grapes.

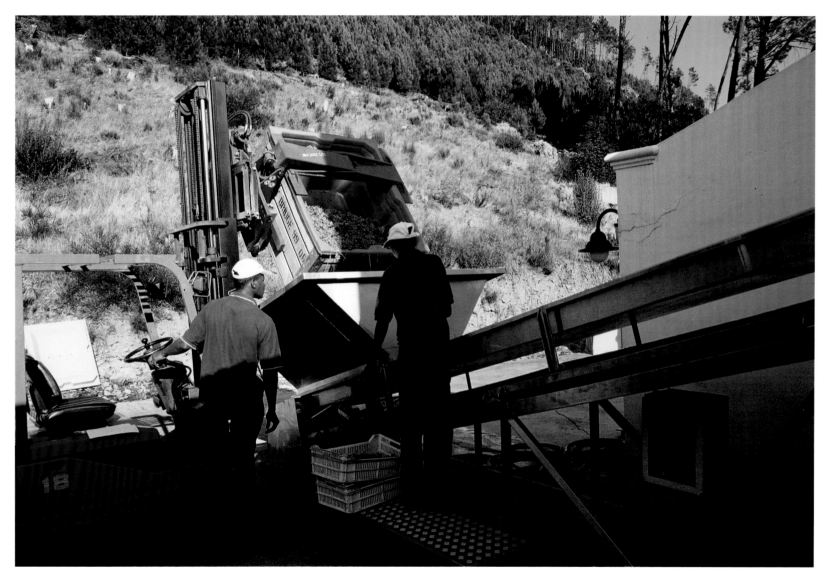

Let the Wine-making Begin

The harvest begins in late January and usually ends in April. Although the grapes are hand-picked, up-to-date technology plays a role in the process. Here, a forklift truck with a bin inverter attachment is used to empty large crates of picked grapes on to a conveyor belt for sorting.

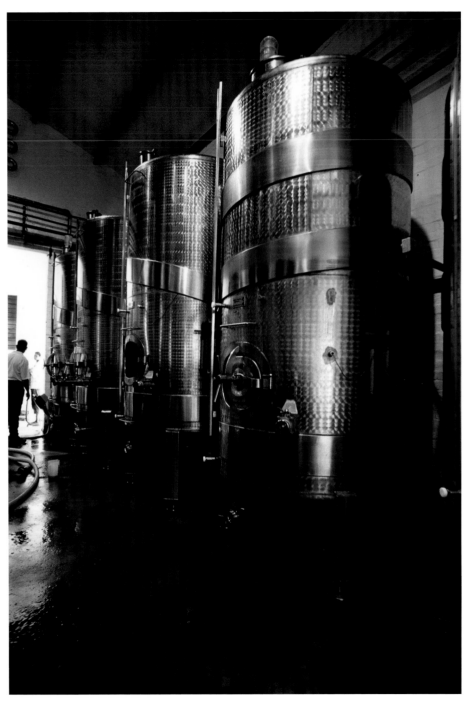

A Scientific Approach

These stainless steel fermentation tanks at Rickety Bridge Winery are used to ferment white wines. The grape juice is left for twenty-four hours to allow solid particles to gravitate down, after which the clearer juice is racked off from the lees and a specially selected yeast is added. The juice is left to ferment for about two weeks, depending on the type of wine that is being produced. Sometimes fermented lees are added back. The wine is then stabilised with bentonyte clay and cooled. The tartaric crystals settle out and are filtered through a diatomaceous earth filter. The procedures are meticulously monitored and the resulting wine is tested by the winemakers before it is bottled.

Fermentation Tanks

A spiral staircase of stainless steel provides access to a gantry above the fermentation tanks and the winemaker's administration offices.

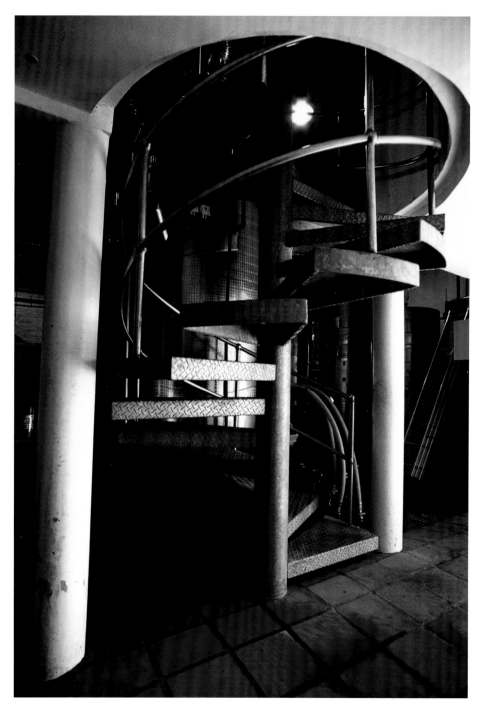

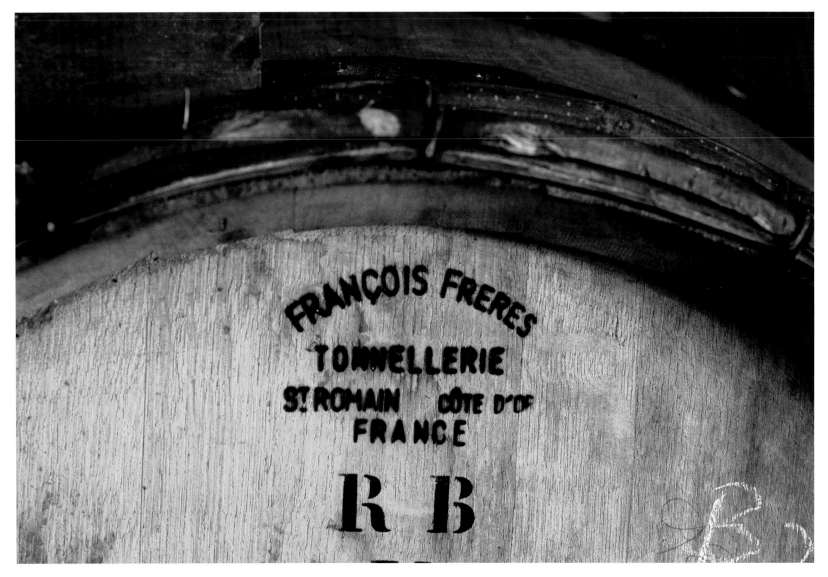

THE COOPER'S ART

At Rickety Bridge Winery only the very best oak barrels, imported from France, will do.

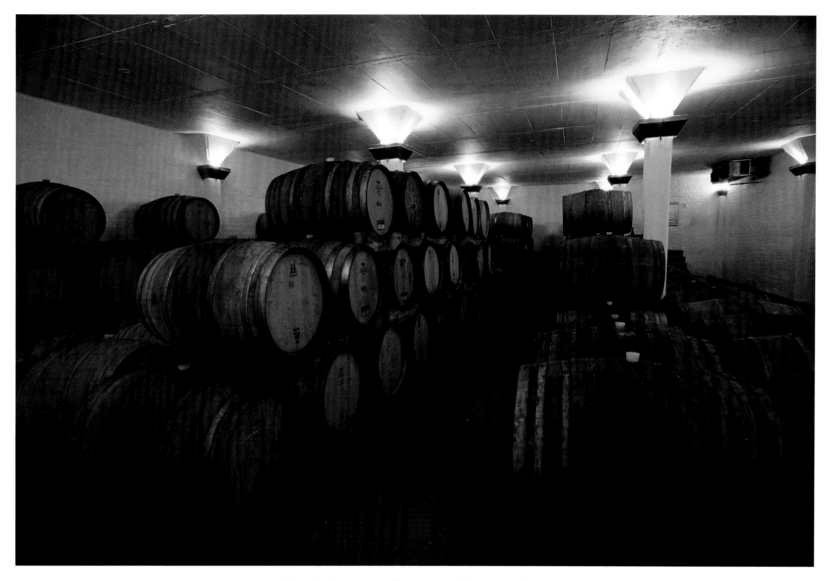

The Magic of Time and French Oak

The barrel cellars at Rickety Bridge Winery ensure that the estate's fine wines are stored at the right temperature and humidity. Time and French oak will make their subtle contributions to the structure and complexity of these award-winning wines.

In 1797 the widow Paulina de Villiers was given a quitrent grant by the Dutch East India Company to obtain land in the historic Franschhoek Valley. It allowed her to occupy the land for at least fifteen years, after which it would revert back to the Company.

Legend has it that on moonlit nights the ghost of Paulina de Villiers can be seen walking through the vineyards and the historic Rickety Bridge Winery Manor House. For over 200 years she has been watching over the land she pioneered and cultivated and the exceptional wines that have been created there since then.

Mina Gqirana, a long-standing staff member at Rickety Bridge Winery, has lived on the farm since the early 1960s. Mina, who looks after the manor house, says that she has felt the smiling eyes of Paulina watching her on many a night – almost as if the ghost is looking after the house.

Winemaker Wilhelm van Rooyen says: 'Being in the old wine cellar sometimes makes the hair on my arms stand on end ... you can't help looking over your shoulder. Lights flicker very strongly some afternoons and then you hear faint footsteps on the staircase.'

Rickety Bridge Winery's award-winning red wine, Paulinas Reserve, is a celebration of the indomitable spirit of Paulina de Villiers. Each year selected barrels of wine are reserved to honour the farm's founder.

The staff at Rickety Bridge Winery enjoy regaling visitors with stories of fine wines and 'spirits'.

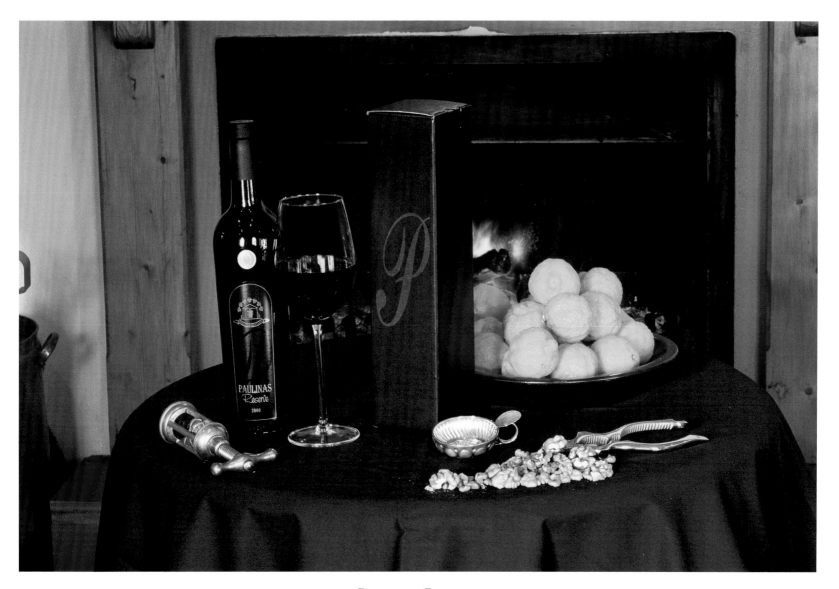

PAULINAS RESERVE

'Wine is bottled poetry.'
– Robert Louis Stevenson (1850–94)

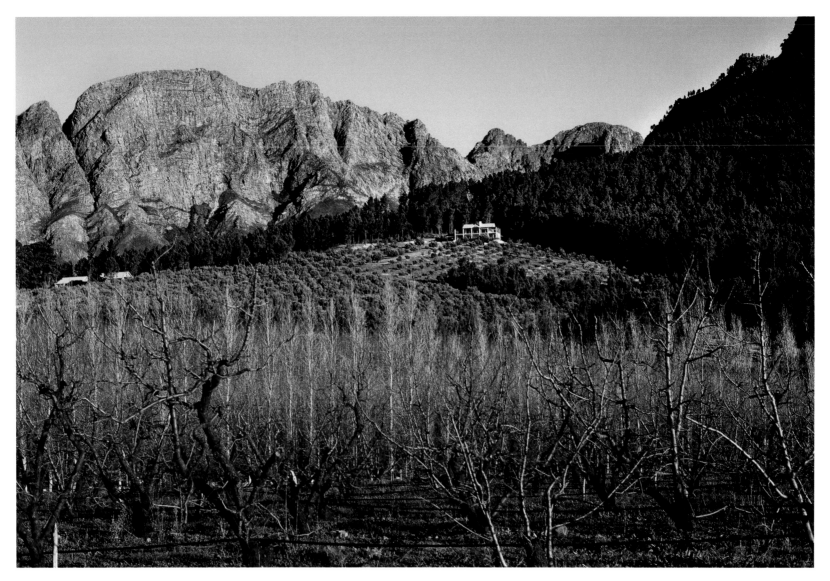

La Bri Holiday and Olive Farm

Set in a breathtaking mountain landscape, La Bri Holiday and Olive Farm is the only farm in Franschhoek with olive groves. During the Second World War, Italian prisoners of war were incarcerated in South Africa. In the main, they were well treated, and many fell in love with the country. After the war ended, some of them remained in South Africa where they would make important contributions to their adopted homeland. One such Italian, Angelo Sabbato, looking for employment after being freed, was offered this mountainside area to cultivate. He successfully planted these olive groves, thus creating Franschhoek's own little Tuscany.

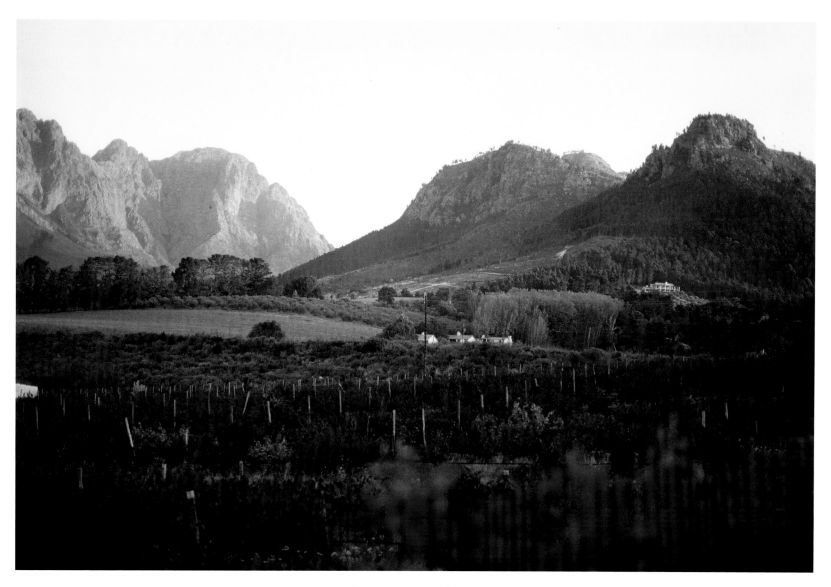

ROBERTSVLEI ROAD

Drive down Huguenot Street and turn right at the Huguenot Monument. After a short distance, turn right into Robertsvlei Road which meanders uphill past some breathtaking scenery. From this vantage point one can see Victoria Peak in the foreground and Skerpheuwel (Sharp Hill) to its left. The dip between the Franschhoek mountains and Skerpheuwel is known as Fortsneck.

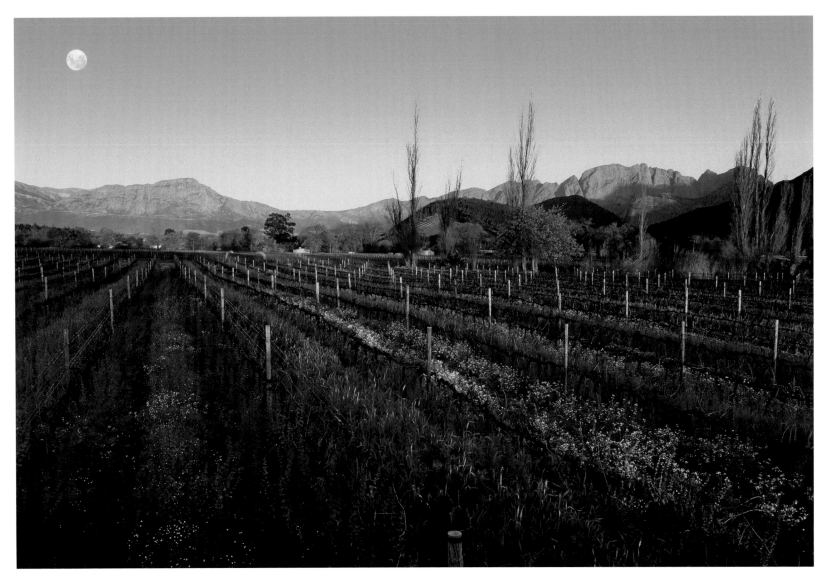

La Motte

In 1695 a piece of land situated in a valley between the Drakenstein mountains and Oliphantshoek was granted to Hans Hattingh, a German immigrant from Speyer. In 1709 his neighbour, French Huguenot Pierre Joubert, purchased the land and named it after the village of his birth in Provence, La Motte d'Aigues. Viticulture was established on La Motte by Huguenot descendant Gabriel du Toit in 1752. Thereafter, the farm passed to successive owners, among them the legendary Cecil John Rhodes. The present owner is Hanneli Koegelenberg, known among music lovers by her professional name, Hanneli Rupert. La Motte was purchased by her father, the industrialist Dr Anton Rupert, in 1970.

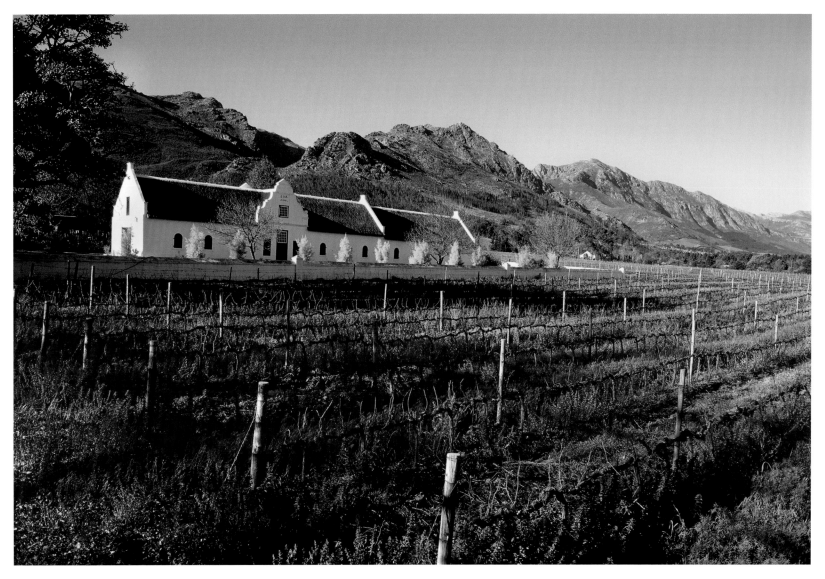

La Motte's Historical Buildings

La Motte has been lovingly restored by the Rupert family to reflect the grace of a bygone era. Declared a heritage site, the La Motte Manor House, the oldest building on the farm, was erected in 1751. An imposing front gable was added eighty-five years later. The late neoclassical-styled pediment is inscribed with the date 1836 as well as the initials of the former owner and his wife – GJJBT (Gideon Jacobus Joubert) and SFRT (Susanna Francina Retief). The Jonkershuis was erected shortly after the completion of the farmhouse and has served as a stable, cowshed and chicken house. The cellar, built around 1782, is the scene of regular classical music concerts.

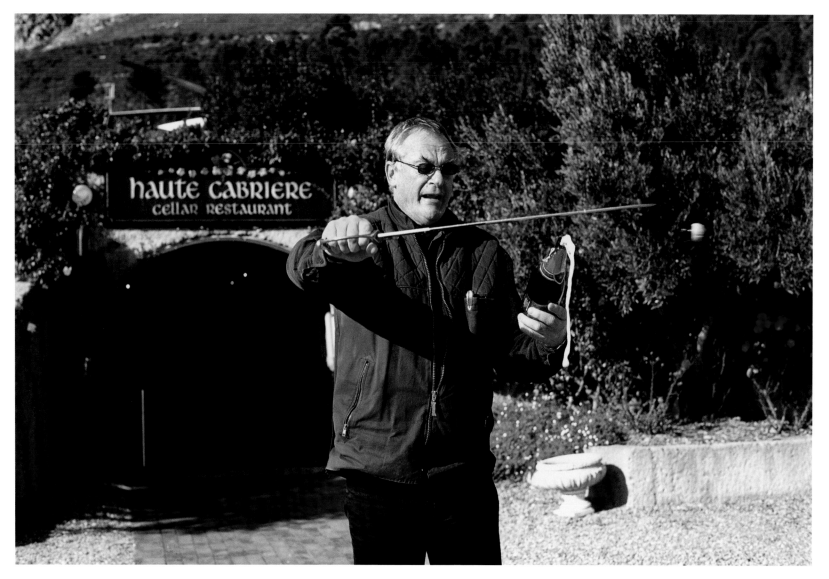

HAUTE CABRIÈRE

Achim von Arnim, a popular Franschhoek celebrity, delights in demonstrating the art of *sabrage* at his Haute Cabrière Cellar Restaurant. With great panache and a flamboyant stroke of his gleaming sabre, he cuts cleanly through the glass neck of a bottle of bubbly. The cork, still intact in the severed glass neck, sails through the air as the sparkling wine gushes out, to the sheer incredulity of his guests. 'French cavalry officers will gladly die for their country but not of thirst,' he quips. Santé!

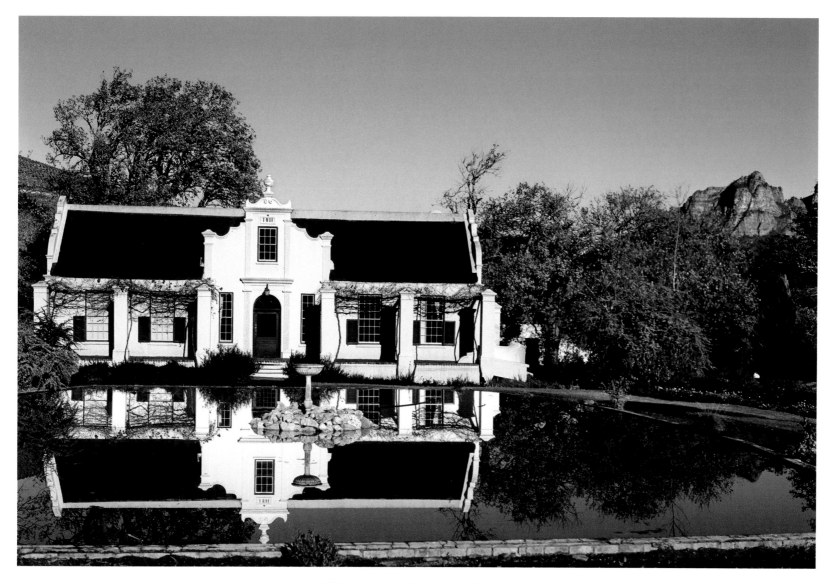

L'Ormarins Manor House

Built in 1811, this elaborate Cape Dutch gable with its central window is a unique feature of the beautifully proportioned L'Ormarins Manor House. The homestead and cellar were built in 1799, and are among some of the oldest buildings of their kind in the Franschhoek area. The restoration of the farm to its former glory is the realisation of the vision of the late Anthonij Rupert. The magnificent mountains to the left and right of the manor house and the terraced vineyards on the surrounding mountain slopes leave the viewer awestruck.

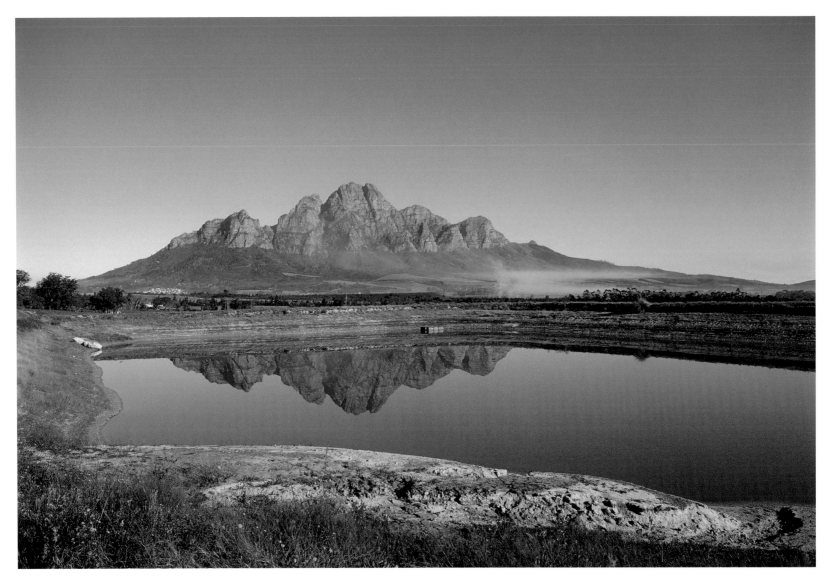

Early Beginnings

L'Ormarins, established by the French Huguenot, Jean Roi, in 1694, offers an awesome vista of Simonsberg. Named after Roi's hometown Lourmarins in Provence, the farm was the first to build its own cellar in the Franschhoek Valley.

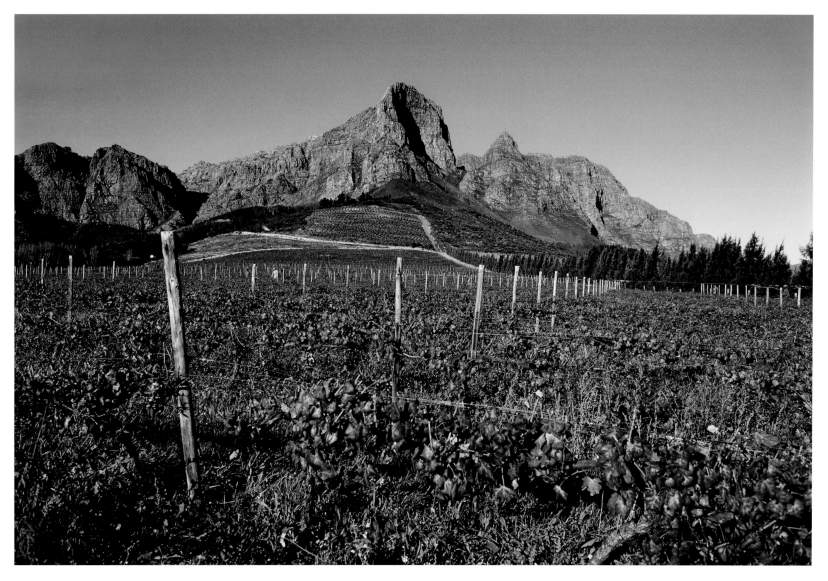

TAPESTRY OF COLOUR

L'Ormarins is a tapestry of colour in early autumn. The russet-coloured leaves accentuate the breathtaking surroundings. Here wildlife can live almost undisturbed.

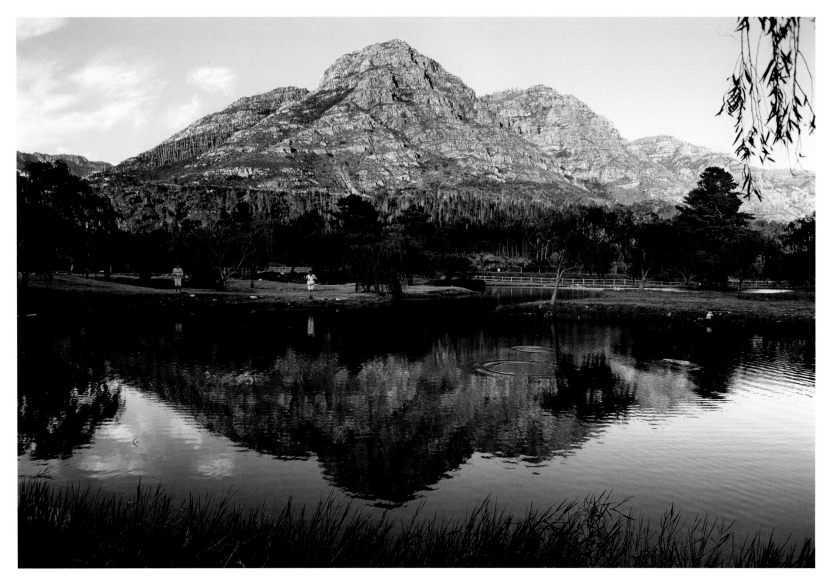

DEWDALE FLY FISHERY

Dewdale farm in the majestic Franschhoek Valley is the premier fly-fishing destination in the Western Cape. One of the Cape's oldest and largest trout farms, it is situated near the headwaters of the Berg River in a dramatic amphitheatre of mountains. It produced some 200 tons of rainbow trout for the table market during the 2001–02 production year.

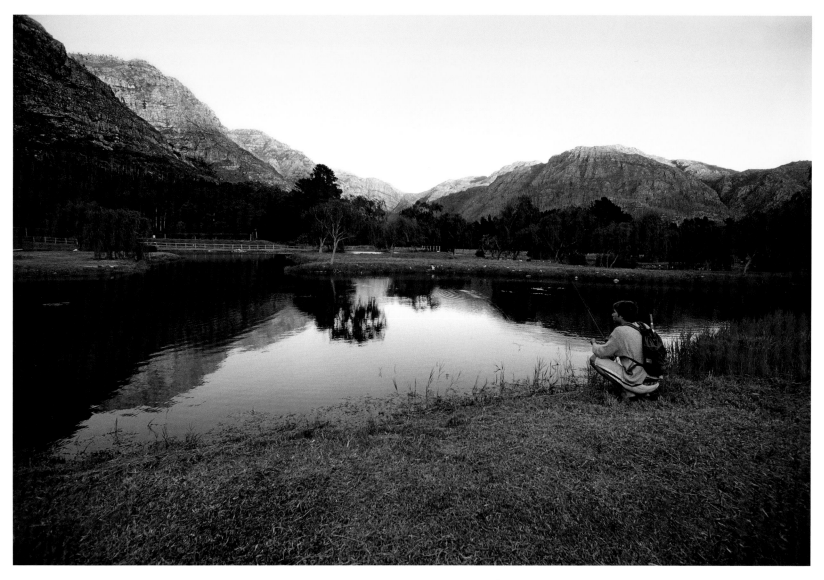

FLY-FISHING PARADISE

The dams at the Dewdale fly fishery offer a variety of fishing conditions, from weeded chalk streams and deep-flowing riverine environments to still water. Tranquillity amid scenic splendour and bracing air – what more could one ask for?

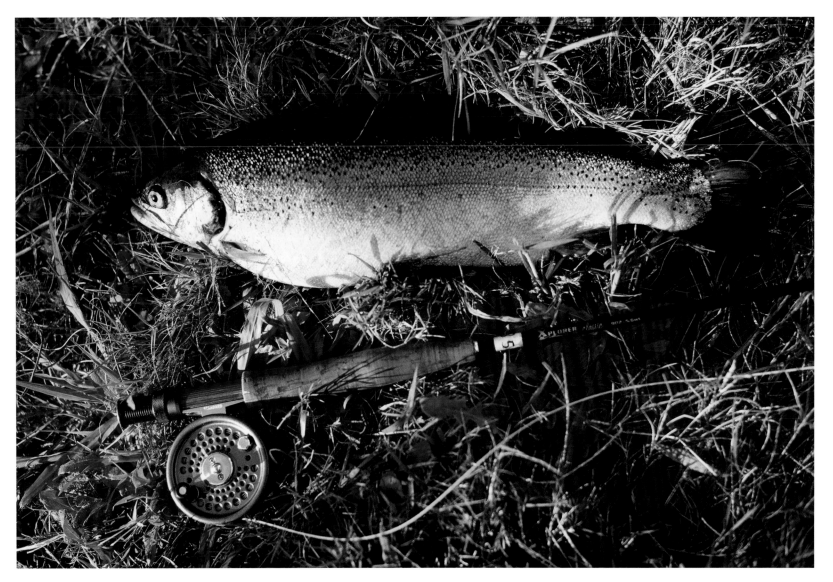

A PREMIER FLY-FISHING DESTINATION

In the past two years more than 2,000 people have been introduced to fly-fishing through the Bell's-sponsored Fly Fishing Academy at Dewdale. The renowned fly fishery has thirteen dams, which are stocked with rainbow trout, brown trout and American steelhead trout. There are also wild populations of sunfish and smallmouthed bass.

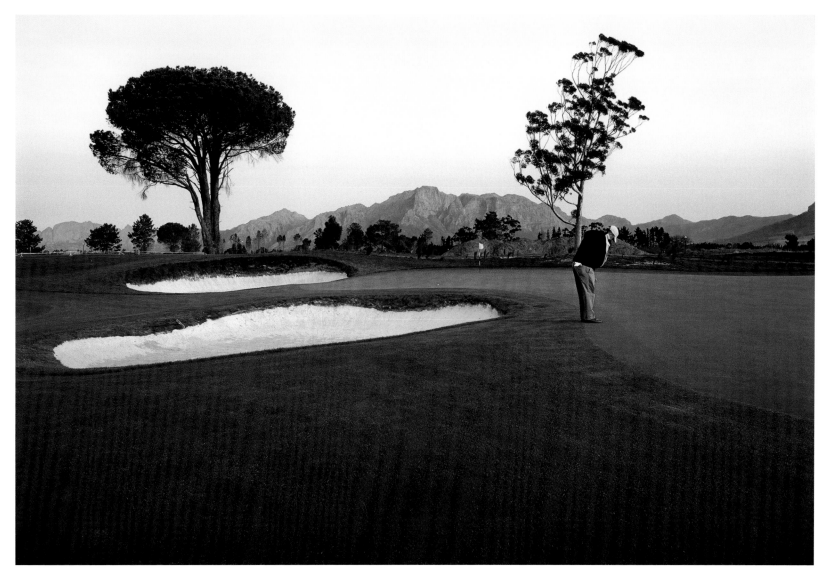

PEARL VALLEY

Just a few minutes drive from the heart of Franschhoek is the *pièce de résistance* of the golfing *fraternité* in the Cape Winelands: Pearl Valley, a 212-hectare estate with an eighteen-hole signature golf course and spa. Ringed by dramatic mountains, it is rated as one of the world's finest golf estates.

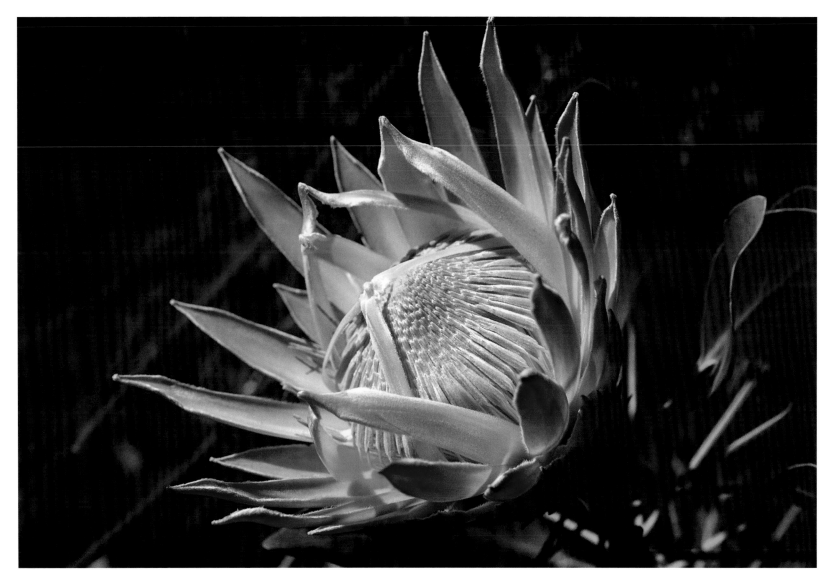

KING PROTEA

Experience the unique flora of the Western Cape on one of the numerous walking trails in the mountains surrounding Franschhoek. The Western Cape is home to the Cape *fynbos* – the world's richest floral kingdom. The striking king protea (*Protea cynaroides*) is one of over 8,500 species in the Cape floral kingdom.

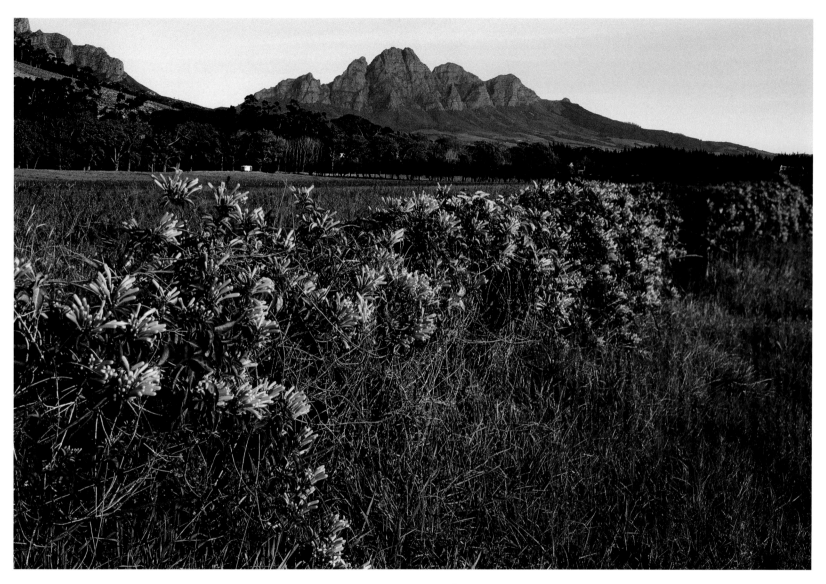

A VALLEY FOR ALL SEASONS

A farm fence of flaming trumpets (*Pyrostegia venusta*) gleaming in the sunshine heralds the arrival of autumn in Franschhoek, a place for all seasons. The majestic Simonsberg stands sentinel.

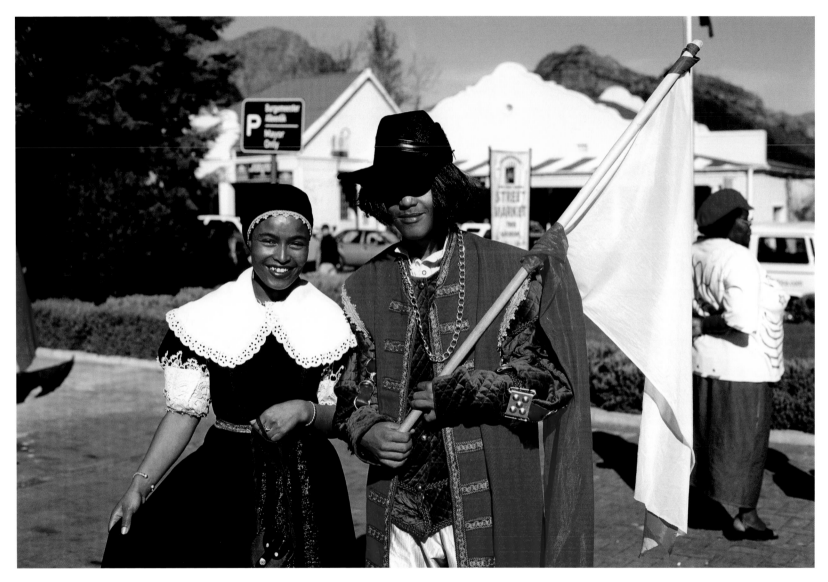

Bastille Festival

Each year, villagers and visitors alike enjoy Franschhoek's annual Bastille Festival. Held in mid-July, the weekend-long festival celebrates Bastille Day (14 July). During 'Bastille weekend', as locals call it, Franschhoek is festooned with the French Tricolour (blue, white and red, the adopted colours of the valley), and the village is alive with activity, entertainment and laughter.

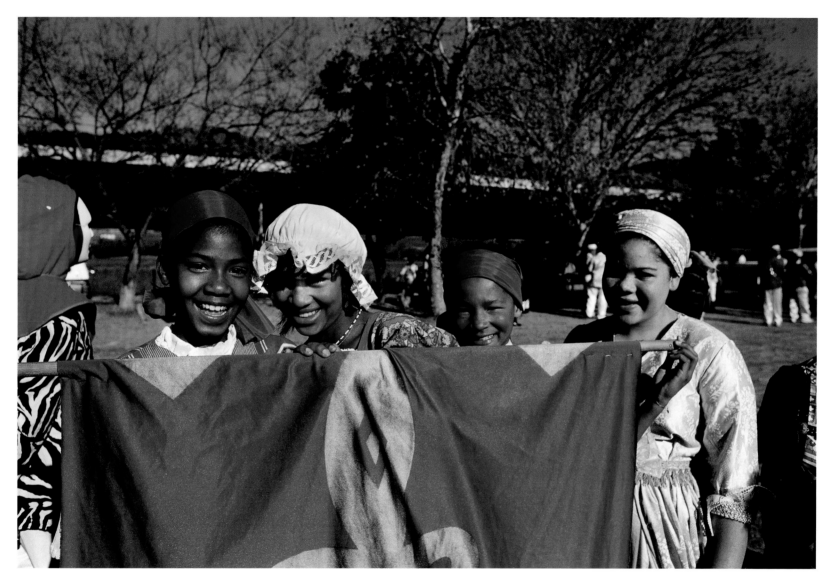

CELEBRATING HISTORY

Rosettes, balloons and buntings of blue, white and red adorn most buildings and farm gateposts during the popular Bastille Festival weekend. At midday on the Saturday of Bastille weekend, the mayoral car makes its way to the town hall where, from the veranda, the mayor will open the festival. Bastille Festival is a celebration of the village's Huguenot heritage and commemorates the storming of the Bastille, the notorious Paris prison, over two centuries ago. The historic event signalled the start of the French Revolution and changed the course of history.

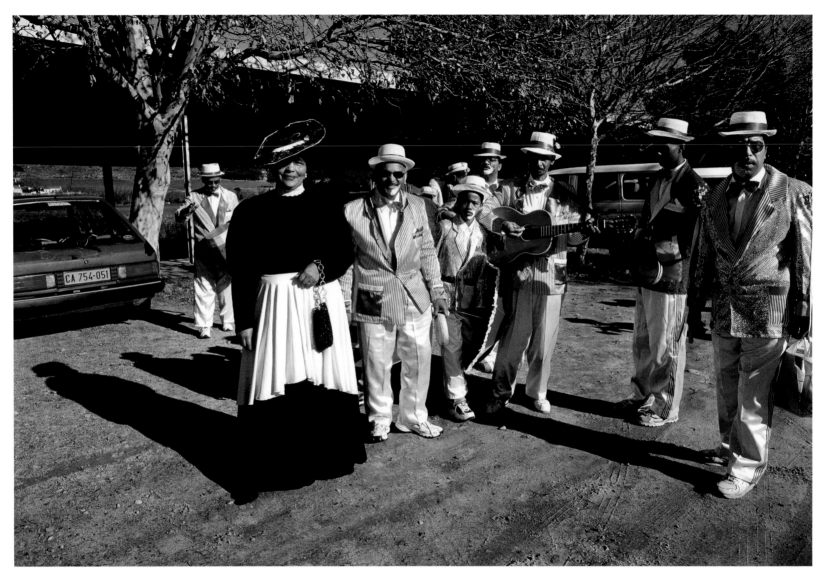

FOOD, WINE AND FESTIVITY

Townsfolk dressed in colourful costumes get ready to perform with a local brass band during the Bastille Festival. The festival is also an occasion to sample the culinary delights of Franschhoek's chefs and to taste some of the best wines created by the valley's master winemakers. Food aficionados wanting to indulge in special Bastille Festival dishes created in their favourite restaurants are warned to book early to avoid disappointment. The active festival committee consisting of members of Franschhoek Vallée Tourisme and Vignerons de Franschhoek works extraordinarily hard in the months preceding the festival to ensure that a seamless, lively, fun-filled weekend in the valley is had by all.

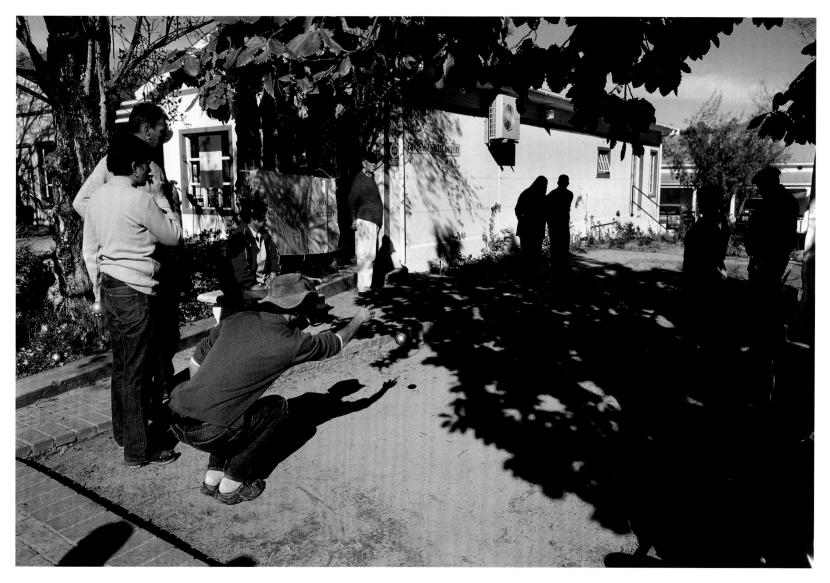

Bastille Festival Pétanque

A game of *pétanque* played in the village draws an appreciative crowd. The word *pétanque* is loosely translated as 'feet tied together', and aptly describes the position from which the metal *boule* is thrown – with the feet kept together and the *boule* thrown underhand, with the palm of the hand facing downward. *Pétanque* games can be played by two people, or in teams of two or three people. A game starts with the opening team throwing a 'jack' a distance of between six and ten metres and ends when one of the teams gets thirteen points and wins. Points are allocated to teams whose *boules* lie closest to the jack.

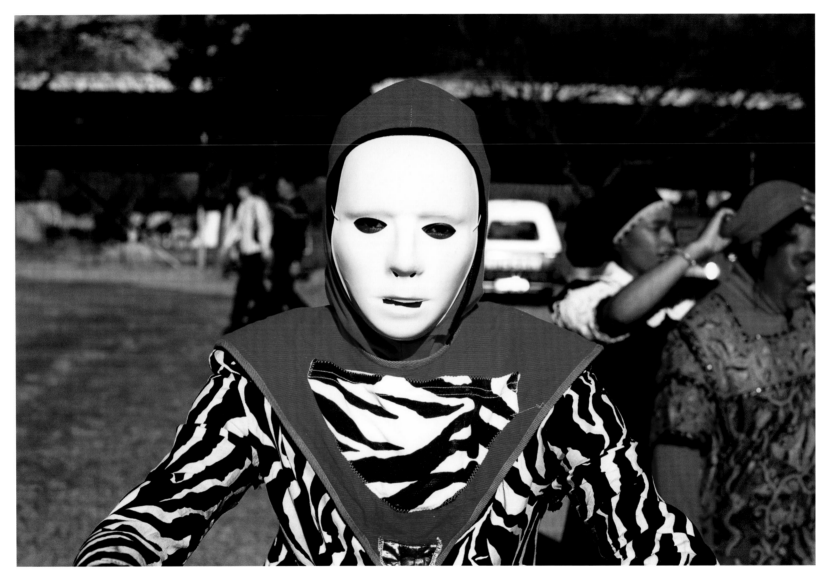

CARNIVAL TIME

There is an exciting carnival atmosphere in the air as village folk don masks and dress up in period costumes resembling the dress once worn by the French Huguenots and other early settlers in the region.

Vignerons de Franschhoek

Felicity Rennie, secretary of Vignerons de Franschhoek, adds a dash of colour to the Bastille Day activities. The association, founded in 1984, strives to uphold the French tradition of wine-growing in the Franschhoek Valley, to encourage the development of quality wine in the valley, and to promote Franschhoek. Its twenty-five members, who include some of the most respected names in the South African wine industry, maintain the highest standards through sharing information. The association's activities extend to helping the needy of the valley and add to cultural and social development in the region.

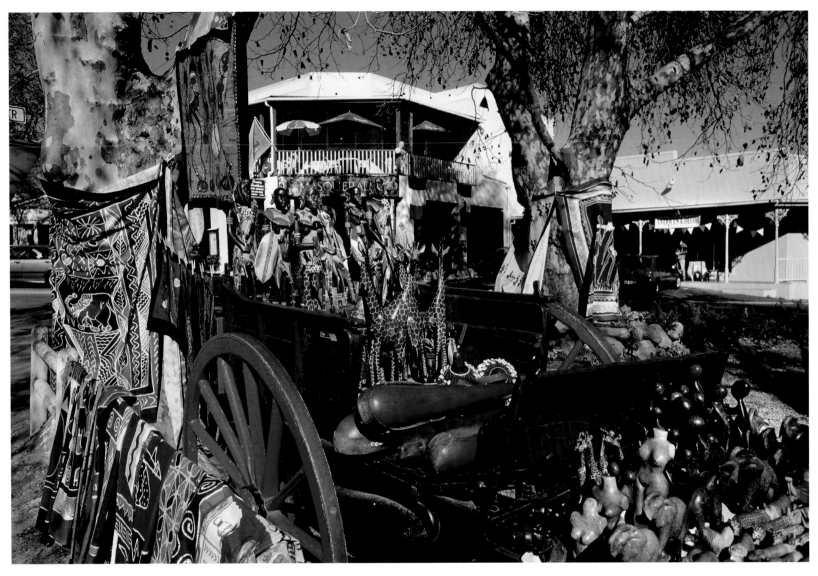

VIVE L'AFRIQUE

An old Cape cart full of curios staffed by French-speaking African immigrants seemed apt on Bastille Day in Franschhoek.

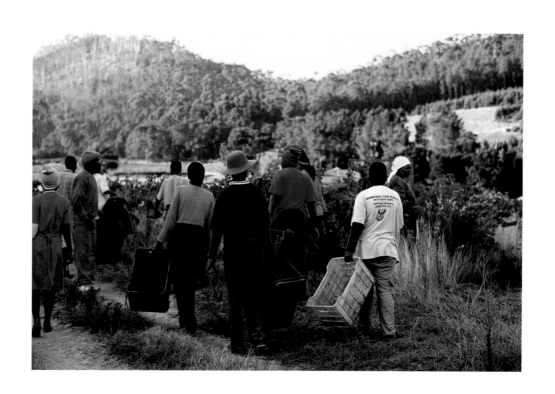

INDEX

Adonis, Denver *44*, 44, 45
Anreith, Anton 30

Basse Provence *61*, 61
Bastille Festival *104–110*, 104–110
Berg River *27*, 27, 69, 98: Canoe Marathon 27
Blaissè family 51
Boschendal *38–39*, 38–39

Cape Dutch furniture *71*, 71
Cape Town *16*
carpets *46–47*, 46–47
Cats, Samuel Johannes 25
Cats' Road *25*, 25
cheese-making 51
chocolates *44–45*, 44–45
Coltart, Linda 48
corkscrews *60*
crafts 11 (*see also* curios; carpets; chocolates; pottery)
cuisine, *see* restaurants
curios *36*, 36, *110*, 110

Dassenberg hill 69
Dawson, Mariaan *76*, 76
De La Rochette, L.S. 22
De Mist, J.A.U. 22
De Villiers, Paulina 88
Dendy Young family 56–57: Carol 56
Dewdale trout farm *98–100*, 98–100
Dieu Donné *5*, *20*, 20
Du Toit, Gabriel 92
Dutch Reformed Church *31*, 31

elephants *18*, 18

flora *102–103*, 102–103
Fly Fishing Academy 100
fly-fishing *98–100*, 98–100
Fortsneck *91*

Franschhoek (town) *24*, 28–36, *37*, 41–43, 44–45, 48–54, 58–60, *104–110*, 104–110
Franschhoek Café *34–35*, 34–35
Franschhoek mountains *26*, *62*, *91*
Franschhoek pass *26*, 26
Franschhoek Vallée Tourisme 106
Franschhoek Valley *5*, 11, 13–15, *13*, *14*, *15*, 18, *20*, 22–27, *22*, *23*, *24*, *26*, *37*, 37–40, 46–47, *55*, 55–57, 61–103, *62*, *72*, *91*: cultivars 14; map *8*; origins of names 22; wines 11
French Huguenots, *see* Huguenots
fynbos 102

Gabbema, Abraham 27
golf *101*, 101
Gqirana, Mina 88
Groot Drakenstein mountains *39*
guesthouses/hotels 11, 48–50, 52–54, 56–57, 61

Hattingh, Hans 92
Haute Cabrière Cellar Restaurant *94*, 94
Helshoogte pass *17*, 17
Huguenot Fine Chocolates *44–45*, 44–45
Huguenot Monument 11, *28–30*, 28–30: Memorial Museum *39*, 39
Huguenots 19, 21, 67, 68, 105: origins *21*, 21
Huxter, Susan 48

Janse, Margot *49*, 49, 50
Jongens, J.C. 28
Joubert, Gideon Jacobus 93
Joubert, Piere 67, 92

Kei Carpets *46–47*, 46–47
Koegelenberg, Hanneli 92

L'Ormarins *95–97*, 95–97: Manor House *95*, 95
La Bri Holiday and Olive Farm *90*, 90
La Frommagerie at La Grange *51*, 51

La Motte *92–93*, 92–93: Manor House *93*, 93
La Petite Ferme *56–57*, 56–57
La Provence 61, 67
Le Café *38*, 38
Le Mouillage 46
Le Quartier Français Auberge and Restaurant *48–50*, 48–50
Le Rhone Manor House *40*, 40
Lloyd, Reverend 54

McEwan, Butch *77*, 77
Mitchell, Olivia 56
Mont Rochelle Mountain Vineyards *37*, 37

Oliphantshoek (Elephant's Corner), *see* Franschhoek Valley
olive groves *90*, 90

Paulinas Reserve 76, 80, 81, 88, *89*
Pearl Valley golf estate *101*, 101
pétanque (game) *107*, 107
pottery *41–43*, 41–43
Protea cynaroides (king protea) *102*, 102
Pyrostegia venusta (flaming trumpets) *102*, 102

Rennie, Felicity *109*, 109
Résidence Klein Oliphants Hoek *52–54*, 52–54
restaurants 11, 24, 38, 48–51, 56–59, 94
Retief, Susanna Francina 93
Rhodes, Cecil John 92
Rickety Bridge Winery 11, 20, *62–89*, 62–89: awards 81; cellars *86–87*, 86–87; cultivars 66; entrance *63–64*, 63–64, *66*, 66; fermentation tanks *84–85*, 84–85; ghost 88; harvesting *79*, 79, *82–83*, 82–83; land use 69; Manor House 67, 69, *70–71*, 70–71; old wine cellar 67, *73*; Paulinas Reserve 76, 80, 81, 88, *89*; slave bell *66–67*, 67;

water feature *73*, 73; winery 77, *83–86*, 83–86; wines 64, 80, 88, *89*, 89; wine-tasting centre 67, *74–76*, 74–76, 88
Rio de Santiago, *see* Berg River
Robertsvlei Road 91
Roi, Jean 96
Roubaix House Gallery *41–43*, 41–43
Rupert Anthonij 95
Rupert, Anton 92

Sabbato, Angelo 90
Simonsberg *15*, *96*, *103*
Skerpheuwel (Sharp Hill) *91*
slavery 68
Spence, Duncan 64
sport, *see* fly-fishing; golf
Steynberg, Coert 29

The Old Corkscrew (shop) *60*, 60
Thibault, Louis Michel 30
Topsi & Company *58–59*, 58–59
town hall *32*, 32, 105
Truckles Traditional Cheese 51

Van Riebeeck, Jan 68
Van Rooyen, Wilhelm *78*, 78, 88
Venter, Topsi 58
Victoria Peak *91*
Vignerons de Franschhoek 106, 109
Von Arnim, Achim *94*, 94

Walters, David *41*, 41–43
Walters, Michelle 41, 43
Walters, Sarah *43*, 43
Wemmershoek mountains *37*, 72
Windvogel, Danny 45
wine estates/farms 11, 20, 37–40, 61, 92–93, 95–97 (*see also* Rickety Bridge Winery)
wine-making 14, 24 (*see also* Rickety Bridge Winery; Vignerons de Franschhoek)